POSTCARD HISTORY SERIES

San Francisco

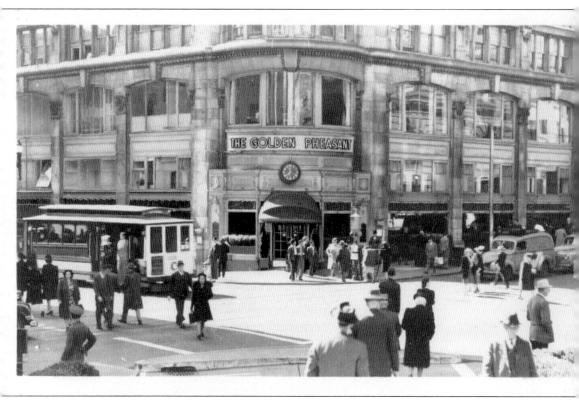

Cable cars first appeared in San Francisco in 1873. Traveling up and down steep hills, cable cars have been celebrated in both songs and poetry and have been the subject of some of the most iconic images of San Francisco. In 1947, an attempt to close down the cable car lines in a cost-saving effort was defeated at the polls. This photo postcard, mailed in 1948, shows one of the remaining cable cars at the intersection of Geary and Powell Streets. (Author's collection.)

ON THE FRONT COVER: A lively photographic postcard by J. K. Piggott shows the Powell Street cable car turntable near Market Street. Automobiles were still allowed on Powell Street and competed with the cable cars for space. This image provides a look at a busy San Francisco day in the late 1930s. The Bank of America is at the same location, while the Owl Drug Company, Clinton Cafeteria, and Pig-N-Whistle Restaurant are long gone. In 1964, the San Francisco Cable Car was declared the first moving landmark on the National Register of Historic Places. (Author's collection.)

ON THE BACK COVER: San Francisco celebrated California's 75 years of statehood with the Diamond Jubilee, a weeklong celebration in September 1925. This dramatic nighttime photo postcard by an unidentified photographer shows the "Arch of Progress" and fireworks with an illuminated city hall in the background. The Diamond Jubilee recognized the pioneer era and symbolically proclaimed the beginning of a new modern era for the city. (Author's collection.)

San Francisco

Robert W. Bowen

ARCADIA
PUBLISHING

Published by Arcadia Publishing
Charleston SC, Chicago IL, Portsmouth NH, San Francisco CA

Printed in the United States of America

Library of Congress Control Number: 2010920586

For all general information contact Arcadia Publishing at:
Telephone 843-853-2070
Fax 843-853-0044
E-mail sales@arcadiapublishing.com
For customer service and orders:
Toll-Free 1-888-313-2665

Visit us on the Internet at www.arcadiapublishing.com

*This book is for Brenda and Chris, third- and fourth-generation San Franciscans,
who have always shared with me an appreciation of their hometown.*

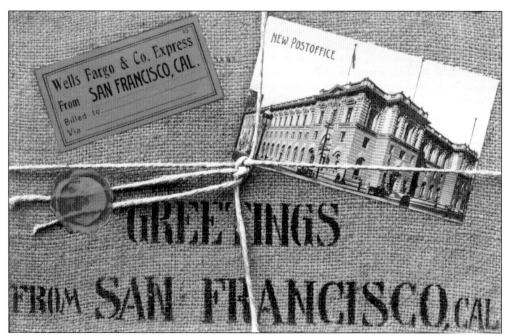

Looking like a nicely tied package, this postcard features a sticker of the Wells Fargo and
Company Express, with a picture of the Main Post Office and Federal Court House on Seventh
Street. The classic white granite building was completed in 1905, survived the earthquake and
fire one year later, and is still a federal courthouse. The postcard was published by I. Scheff and
Brothers of San Francisco, Berlin, and Prague. "Greetings from San Francisco, Cal."

CONTENTS

ACKNOWLEDGMENTS

I would like to express my gratitude to all the historians, authors, librarians, teachers, park rangers, and docents for their contributions in keeping the stories of San Francisco alive and preserving the history of this unique and special city. Their numbers are too great to even attempt to list them all.

San Francisco has many organizations devoted to providing an awareness of the city's history. I have found these organizations particularly beneficial in my study and appreciation of San Francisco history. I would especially like to acknowledge the San Francisco Bay Area Postcard Club (www.postcard.org), the San Francisco History Association (www.sanfranciscohistory. org), the San Francisco Museum and Historical Society (www.sfhistory.org), the National Park Service, Golden Gate National Recreation Area (www.nps.gov/goga/index.htm), the San Francisco History Center (www.sfpl.org/librarylocations/sfhistory/sfhistory.htm) and San Francisco City Guides (www.sfcityguides.org). While all of the illustrations used in this book are from the author's personal collection, it was through these organizations that I was able to learn many of the stories behind the picture on the front of the postcard.

I would also like to extend special thanks to Jeff and Barbara Staley for detailed information on the Chinese Children's Choir shown on page 61.

Finally, I would like to thank my editor John Poultney for his support, and Arcadia Publishing for their vision in keeping alive regional and community history and for providing the resources to share that history.

INTRODUCTION

The city of San Francisco sits on the tip of a peninsula surrounded on one side by the Pacific Ocean and the San Francisco Bay on the other. The bay is one of the world's largest and most scenic landlocked harbors. The entry to the 400-square mile bay is a 3-mile opening originally called "La Boca" (the mouth) by the Spanish and later named "Chrysopylae" or "Golden Gate" by the explorer and cartographer John Charles Fremont. When the Spanish first arrived in 1776, they found a foggy mass of rocky sand hills and dunes sparsely covered by laurel trees, shrubs, grasses, and saltwater wetlands. Fresh water trickled down from the hills in creeks and streams feeding into lakes, lagoons, and the bay.

The San Francisco peninsula was the homeland of the Yelamu, an Ohlone linguistic and cultural people who had lived in the area for several hundred years. They moved seasonally from winter village to summer/fall villages looking for game, plants, and fish. When the Spanish arrived in 1776, there were over 200 Yelamu in the area. By 1850, there was only one known Yelamu, Pedro Alcantra. While archaeological evidence provides a record of over 4,000 years of native people in the area, the Yelamu left behind no illustrative evidence of their lives.

Europeans found their way to the bay with Gaspar de Portola's discovery in 1769. Spanish colonization of the area began a few years later out of concern that either Russia or Great Britain would try to take it. Juan Manuel de Ayala arrived by ship in 1775, reporting that the harbor was "the best he had seen in those seas from Cape Horn north." Finally, on September 17, 1776, the first Spanish outpost was established by Jose Joaquin Moraga, a soldier serving with Juan Bautista de Anza, who arrived with a band of nearly 200 soldiers and settlers. On October 9, 1776, Padre Francisco Palou dedicated the Catholic Mission of San Francisco de Asisi, which would be known as Mission Dolores for its location near a small lake, Laguna de los Dolores (Lake of Sorrows). Except for gun batteries and a few adobe buildings of the Presidio and the Mission, the Spanish produced little physical development of the region. They certainly produced nothing in the way of illustrated records. Paintings by visiting Russian artist Louis Choris in 1816 and the British naval artist Richard Beechey in 1826 provide the best visual documentation of the area during the Spanish and Mexican periods. Mexico had gained independence from Spain and control of California in 1822. With increasing numbers of traders appearing in the harbor, a small commercial community appeared on Yerba Buena Cove (near present-day Portsmouth Square).

Americans took control of Yerba Buena and the Presidio during the Bear Flag Revolt of 1846. Following the war with Mexico, the Treaty of Guadalupe Hidalgo (February 2, 1848) gave California to the United States. Within days of the treaty, the discovery of gold brought thousands of men and women to the shores of San Francisco Bay seeking their fortunes. As a major port of entry to the gold fields, the newly renamed city of San Francisco quickly became the leading commercial center on the Pacific Coast and increased in population to almost 42,000 people by the end of 1852.

Just a few years before the discovery of gold, a new scientific discovery allowed the mid-century Argonauts an opportunity to actually visually document themselves in a relatively inexpensive way. The daguerreotype was a way reproducing images from life through a lens on iodized silver plates. Anyone of means could preserve themselves for posterity. Within a

short time, cheaper methods of the photographic process were developed, images on tin called ferreotypes, and cartes-de-visites or visiting card portraits. Throughout the later half of the 19th century, San Franciscans dressed in their best clothes visited commercial photographers to have their portraits taken. Early local photographers Lawrence and Houseworth, Henry Bradley, William H. Rulofson, Carleton Watkins, and Isaiah West Taber began to document the city and the surrounding landscapes to sell as mementos. They created three-dimensional stereographic view cards, 5-inch-by-7.5-inch cabinet cards, and some photographers like Taber marketed their views in large albums of photographs. As San Francisco continued to develop as a commercial, financial, and recreational center, these photographers fulfilled the needs of both residents and visitors for personal documentation.

Throughout the remainder of the 19th century, the city continued to grow in size and importance, overcoming earthquakes and fires, surviving vigilante justice, and sandlot riots. In 1894, San Franciscans enjoyed the California Midwinter International Exposition showcasing technology, commerce, art, and fun events. The Midwinter Fair was documented on beautifully printed trade cards and souvenir booklets. Within a few short years, as San Francisco entered the 20th century, a new form of inexpensive documentation would be available to record and show off the city by the bay, the picture postcard.

The noted city historian Oscar Lewis wrote in 1966, "the historian's task is made easier by the fact that San Francisco is one of the most thoroughly documented American cities, hence there is no lack of material from which to draw." In a book using postcards as both the subject matter and as a historic resource, there is certainly no lack of material from which to draw. Every postcard provides a visual record of how the city once looked and behaved. Every postcard has a story to tell, either from the image on the front of the card or from the personal messages written on the back.

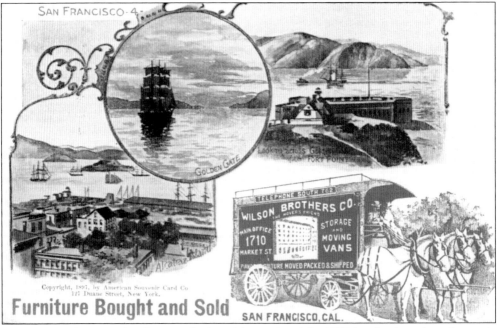

This is an early example of postcard advertising, printed in 1897 by the American Souvenir Card Company of New York for the Wilson Brothers storage and moving company. The card featured a montage of San Francisco images, North Beach, Alcatraz Island, Fort Point, the Golden Gate, and the Wilson Brothers wagon pulled by a team of white horses.

One

POSTAL CARDS AND
PRIVATE MAILING CARDS

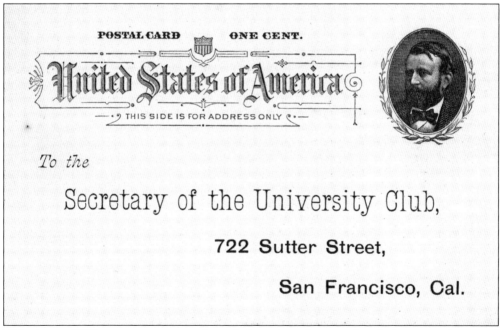

This is an 1892 government postal card featuring the preprinted 1¢ stamp image of Pres. Ulysses Grant, intended to be used as a response to a dinner invitation at the University Club. The earliest postal cards and postcards were published primarily for business use. The first nongovernment postal card in the United States was copyrighted on December 17, 1861, by J. P. Charlton and published by H. L. Lipman, both of Philadelphia. The early cards were promoted as offering great facilities for sending messages or for rapid correspondence. Postal cards were sort of the email or text messaging of their day. The U.S. Post Office began selling postal cards on May 13, 1873. After purchasing their cards, a business or organization would have their messages imprinted before mailing.

Please bring this Card with you to the Lodge-room. *BKWN*

VALLEY LODGE, No. 30, A.O.U.W. Assessments Nos. 9 & 10.

DEAR SIR AND BROTHER: *San Francisco, June 7th, 1882.*

You are hereby notified that the following deaths have occurred in our Order:

o. Death	Name.	Age	Lodge and Number.	Location.	Date of Death.	Cause.
57	J. F PHILLIPS,	48	Lone Syca'ore L'ge, No.163	Lemoore	April 5, 1882	Pneumonia
58	EVANS D. EVANS,	46	Bridgeport Lodge, No. 107	N. San Juan	Mar. 17, 1882	Typhoid Pneumonia
59	HENRY MANNING,	26	California Lodge, No. 1	West Oakland	April 8, 1882	Accidental Scalding
60	ISAAC A. LAWSON,	28	Butte City Lodge, No. 206	Apr. 19, 1882	Inflammation of Brain
61	HENRY KUHL,	46	San Francisco Lo'ge, No. 4	San Francisco	Apr. 22, 1882	Consumption
62	JULES L. BARBEY,	47	Riverside Lodge, No. 120	Compton	Apr. 22, 1882	Suicide
63	WM. H. LUNDY,	52	Los Gatos Lodge, No. 76	Los Gatos	Apr. 23, 1882	Dropsy
64	PAYTON POWELL,	51	Main Top Lodge, No. 156	Michigan Bluff	May 2, 1882	General Debility
65	JOSEPH P. BROGAN,	34	Mountain Lodge, No. 105	Truckee	May 6, 1882	Suicide
66	JOHN SMITH,	42	Laurel Lodge, No. 134	Susanville	May 16, 1882	Caving of Gravel Bank

You are hereby notified that **ONE DOLLAR** is required of you to pay Assessment No. 9, and if not paid on or before the **28th inst.**, your **Beneficiary Certificate will be suspended.**

Assessment No. 10 will be paid from the Reserve Assessment and General Funds of the Lodge.

Also, for Dues to188 , $...........

Received Payment, June 1882. J. M. CAMP, Financier,

P. O. ADDRESS: 311½ ELM AVENUE.

...*Financier.*

This is a June 7, 1882, Valley Lodge, No. 30 Ancient Order of United Workmen (AOUW) assessment postal card. The philosophy of the AOUW, founded in Meadville, Pennsylvania, in 1868, was based on the premise that every person is his "brothers" keeper. Each member paid $1 into an insurance fund to cover benefits to a member's dependents when he died. Surviving members were reassessed each time a member died. The postal card lists the names, lodges, and the cause of death.

The front side of the AOUW government postal card allowed nothing but the address and preprinted postage. It was not until 1907 that laws were changed about what could appear on the front of the card. Prior to 1898, if the message on the card was personal or in manuscript, the full letter rate postage was applied.

Wholesale grocers Tillmann and Bendel, located at Clay and Battery Streets, mailed out this advertising postal card in July 1888 to promote their line of fine cigars. San Francisco was the premier commercial port of call on the West Coast with local wholesalers importing a wide variety of products from Asia, Central, and South America.

This is the address side of the Tillmann and Bendel card when only the government was allowed to use the words "postcard" or "postal card." Privately published cards of the period were titled "souvenir card," "correspondence card," or "mail card." Government cards were imprinted with either a Grant or Thomas Jefferson head 1¢ stamp on them. Privately published postcards required a 2¢ postage stamp.

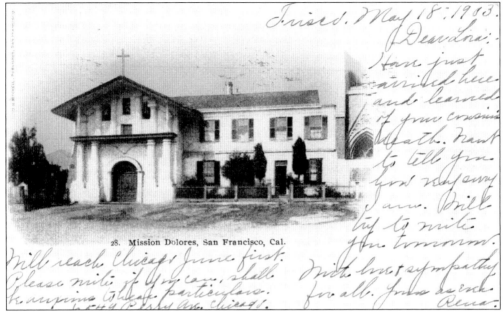

28. Mission Dolores, San Francisco, Cal.

This is an early view of Mission Dolores, published by E. H. Mitchell. The oldest building in San Francisco, the church was constructed of 4-feet thick sundried adobe by Native American laborers. The building has no nails, but manzanita pegs and rawhide thongs have held it together through several earthquakes. Architect Willis Polk renovated the mission to its original state in 1920.

On May 19, 1898, by an act of Congress, private printers were allowed to print and sell cards that bore the inscription "private mailing card." The postage charge for mailing a private mailing card was reduced from 2¢ to 1¢. The reduced postage rate plus improvements in lithography and offset printings spurred printers on in the production of private mailing cards. Personal messages were now allowed on the image side only, and as seen on this Mission Dolores card, every blank space was used for correspondence.

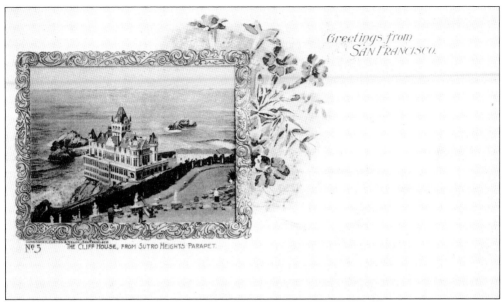

The Cliff House, "Adolph Sutro's gingerbread palace," became a instant landmark when the Victorian resort was first erected in 1896 on a precipice overlooking the Pacific Ocean. The view on this card, published by Cunningham, Curtiss, and Welch, shows Sutro's sculpture-laden parapet, with the building and seal rocks in the background. In the 1890s, horse-drawn omnibuses carried visitors to Sutro's from Portsmouth Square for a fare of 50¢. The Cliff House survived the 1906 earthquake but burned to the ground in 1907.

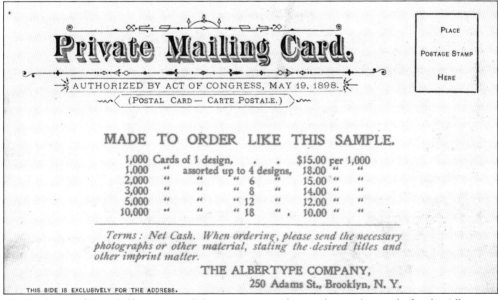

The backside of the Cliff House card shows it was used as a salesman's sample for the Albertype Company of Brooklyn, New York. Albertype was a major publisher of photographic books as well as "private mailing cards." The name "Albertype" refers to a printing process, creating a monotone gray-black resembling photogravure. The size of the orders available on this sample show just how popular postcards were becoming; everyone was mailing cards, and everyone was saving them.

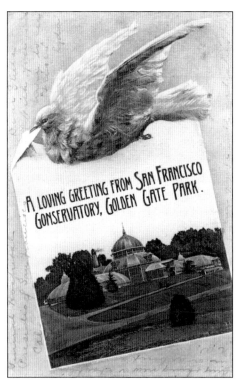

Publisher I. Scheff and Brothers demonstrated artistic creativity on this postcard of a carrier pigeon bearing a message of "a loving greeting from San Francisco," with a view of the Conservatory of Flowers in Golden Gate Park. A large glass structure modeled after the Royal Conservatory at Kew Gardens, it was rebuilt in 1882. The conservatory, with its international collection of semitropical plants, was a popular destination for visitors to the park.

The words "post card" were officially allowed to be used beginning December 24, 1901. Within a few years, regulations would be relaxed to allow personal messages to be written on the same side of the card as the address and postage, leaving the front of the card for illustrations. The publishing of printed postcards during this period doubled almost every six months, with millions of cards being printed. It was the beginning of the Golden Age of Postcards.

Two

GOLDEN AGE OF POSTCARDS

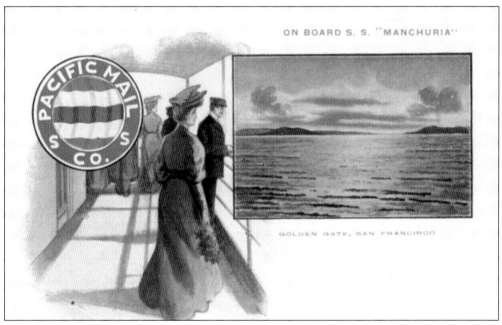

The "On Board S. S. 'Manchuria' " advertising postcard for the Pacific Mail Steam Ship Company features a view of the Golden Gate. In 1848, the Pacific Mail Company began service from New York to San Francisco, via a land crossing over Panama. The Pacific Mail ships were the main transportation and communication link with the rest of the United States. After completion of the transcontinental railroad in 1869, the company emphasized transpacific service with Asia. Printing techniques were used to make postcards like this advertising card appealing. In the photogravure process, a photograph was hand-colored. The printer would separate each color by photographing the image using filters. Each color would be blocked-out except one. The process would be repeated for each color. The printer would run the paper stock through the press for the color used, let the paper dry, and then run the next color. After all the colors were run through the press, the printer had created a miniature work of art suitable for mailing and for collecting.

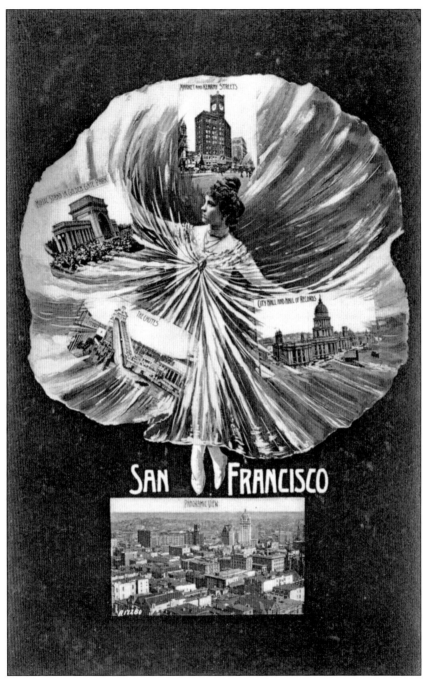

The "Spirit of San Francisco" was represented by this illustration of an attractive young woman, her gown swirling around a pictorial display of popular destinations: the Chronicle Building, the Music Stand in Golden Gate Park, the Chutes amusement center, city hall, and the Hall of Records. A panoramic view of the city appears at the bottom of the card. This I. Schiff and Brothers postcard was printed in Germany. Nearly 75 percent of all postcards sold in the United States at this time were printed in Germany, a country noted for its superior high-quality printing.

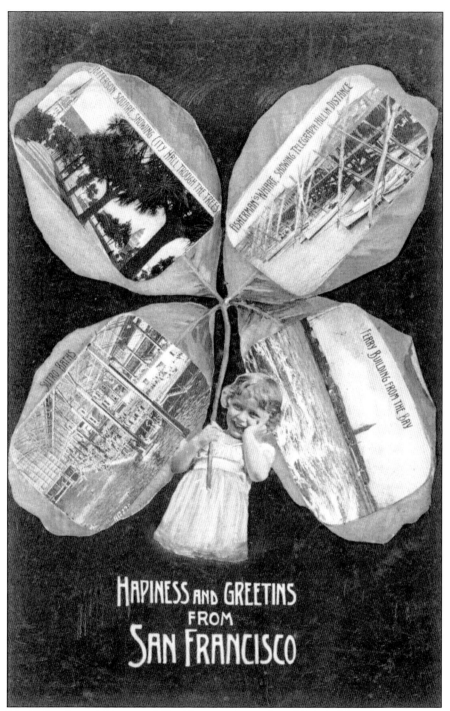

The Scheff Brothers, Isidore and David, were located at 1103 Golden Gate Avenue. They produced this four-leaf clover montage featuring a little girl, with deliberate misspelling to create a sense of "baby talk" in this greeting. The artist who created this card literally cut and pasted images of Jefferson Square, Fisherman's Wharf, the Ferry Building, and Sutro's indoor swimming pool.

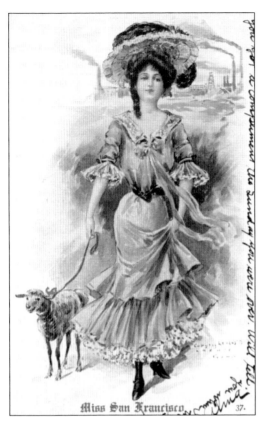

Miss San Francisco, 37.

"You got a compliment the Sunday you were over," reads the message for this National Art Company postcard of "Miss San Francisco," a beautiful Gibson Girl in a grand hat walking her lamb. This unusual postcard has the young lady walking away from industrial stacks billowing smoke in the background. Early postcard publishers frequently recycled images only changing the colors and the captions.

The Frisco girl
on western shore—
A kiss or two
she would adore.
Not just two—but
many more!
Under the mistletoe.

In the early days of the 20th century, it was all right to call San Francisco "Frisco." It was a nickname for the city usually said with affection and appreciation. The "Frisco girl" was "Miss San Francisco." To quote the poem, "The Frisco girl on western shore—a kiss or two she would adore."

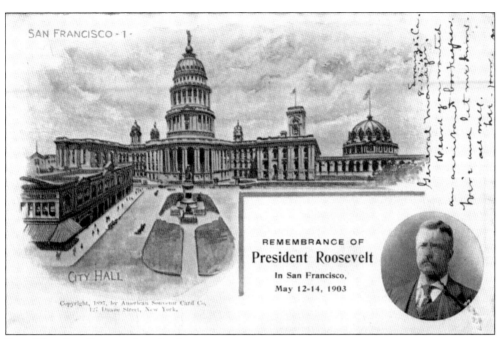

REMEMBRANCE OF
President Roosevelt
In San Francisco,
May 12-14, 1903

CITY HALL

Copyright, 1897, by American Souvenir Card Co,
127 Duane Street, New York.

Pres. Theodore Roosevelt arrived in San Francisco on May 12, 1903. The following day Mayor Eugene Schmitz declared a municipal holiday. Thousands of people, including school children, turned out to greet the popular chief executive. For the first time in history, African American Troops I and M of the U.S. Army 9th Cavalry were assigned as a Presidential Honor Guard for Roosevelt's journey from the Palace Hotel to the Presidio Golf Links. To commemorate the president's visit, an American-Souvenir card with a painting of city hall was overprinted with a photographic remembrance of President Roosevelt in San Francisco. The vertical Scheff Brothers card included the president's visage alongside illustrations of the art museum and music stand in Golden Gate Park, the Cliff House, and Sutro's Baths.

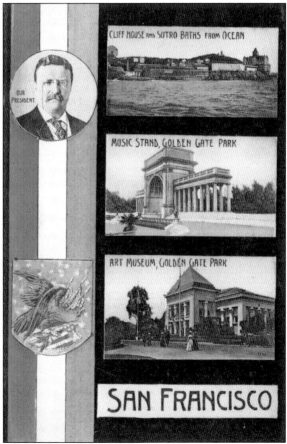

CLIFF HOUSE and SUTRO BATHS from OCEAN

MUSIC STAND, GOLDEN GATE PARK

ART MUSEUM, GOLDEN GATE PARK

OUR PRESIDENT

SAN FRANCISCO

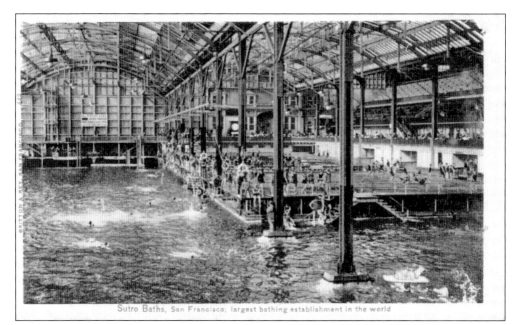

Sutro Baths, San Francisco; largest bathing establishment in the world

Sutro's Baths, the largest and grandest bathing establishment in the world, was built on the bluffs overlooking the Pacific Ocean by wealthy mining engineer Adolph Sutro in 1894. Bathers could rent a wool suit for 25¢ and swim under a glass-roofed ceiling in one of seven indoor pools. The saltwater L-shaped pool pictured in this Britton and Rey postcard was the largest pool, measuring 175 feet by 300 feet.

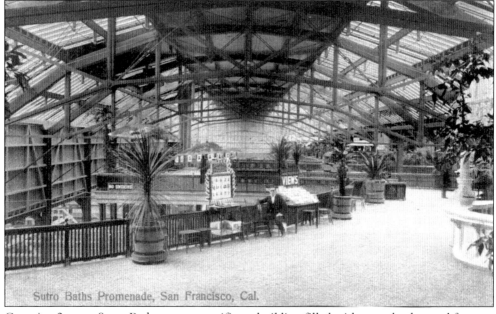

Sutro Baths Promenade, San Francisco, Cal.

Covering 2 acres, Sutro Baths was a magnificent building filled with potted palms and ferns, as seen in this I. Scheff and Brothers view of the promenade with a lone vendor selling postcard views. Admission for nonswimmers was 10¢ to use the restaurants, visit Sutro's museum of oddities, or play the penny arcade mechanical machines. The building burned to the ground in 1966.

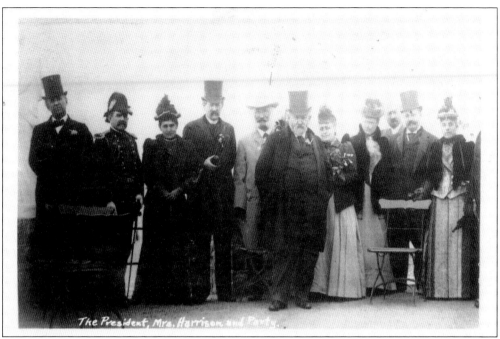

The President, Mrs. Harrison and Party.

Adolph Sutro, in the center of the photograph with the white hat, at one time owned one-twelfth of the city and county of San Francisco. He served as the city's Populist mayor from 1895 to 1897. Sutro frequently invited guests to his home at Sutro Heights, including Pres. Benjamin Harrison and his party on April 25, 1891. A large bull sea lion on Seal Rocks was named Benjamin Harrison Cleveland in honor of the two presidents.

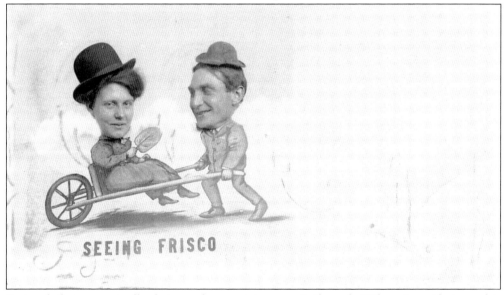

SEEING FRISCO

Postcards that were actually photographs came into vogue in the early 20th century. Photographic paper was available in the standard 5.5-inch-by-3.5-inch postcard size with preprinted postcard backs. Professional and amateur photographers took the opportunity to use their Kodak cameras to create their own unique picture postcards. This image of a couple in derby hats "Seeing Frisco" was probably made in a penny arcade.

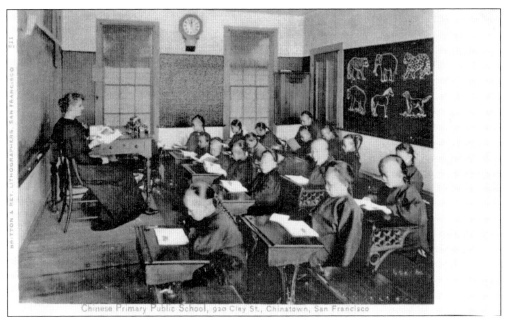

Chinese Primary Public School, 920 Clay St., Chinatown, San Francisco

The Chinese Primary Public School at 950 Clay Street in Chinatown was illustrated on a Britton and Rey postcard. This segregated school was established in 1887 after Mary Tape was denied entry to one of the city's public schools solely because she was Chinese. Her parents sued, and the court ruled that all children, regardless of race, had the right to a public school education.

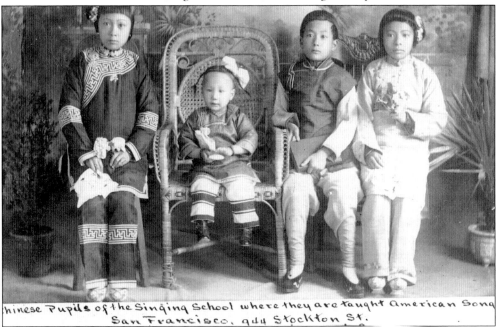

Chinese Pupils of the Singing School where they are taught American Song San Francisco, 944 Stockton St.

Chinese pupils of the Singing School at 944 Stockton Street were taught American songs. The children were dressed in their best traditional holiday clothes for their performances, which were usually fund-raising activities for missionary societies. There were at least 10 Western churches within Chinatown, which played a significant role in the life and society of the local Chinese community. The Cardinell Vincent Company published the photo postcard.

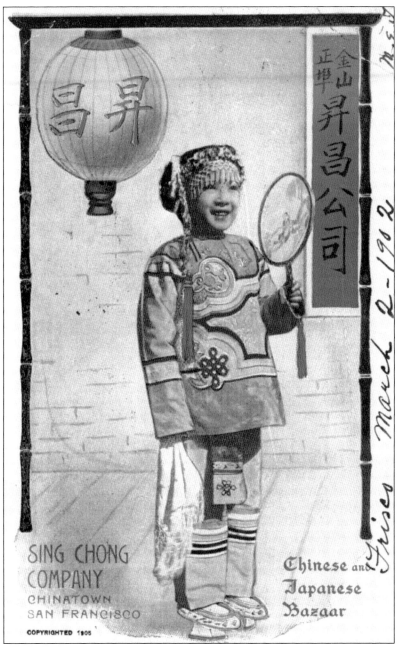

The Sing Chong ("Living Prosperity") Company, located at California and Dupont (later renamed Grant) Streets, was one of Chinatown's most successful businesses, selling both Chinese and Japanese imported merchandise. The Sing Chong Company was incorporated in 1905, and for many years was managed by Chinese American Look Tin Eli. The same year the company incorporated, the company published their own postcards. This advertising postcard features a smiling, young girl wearing embroidered holiday clothing. Following the 1906 earthquake and fire, the Sing Chong Company, along with their neighbor, the Sing Fat Company, hired the architect and engineering team of Ross and Burgen to design pagoda-style buildings creating what Look Tin Eli described as a new "Oriental City."

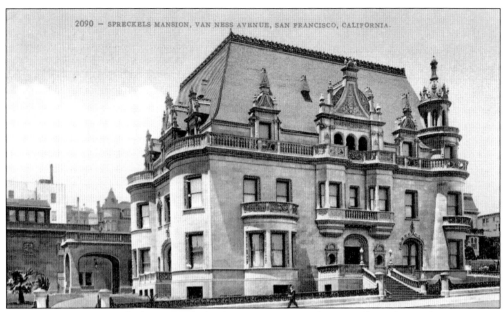

The elegant mansion of Claus Spreckels, the "Sugar King of Hawaii," was located on Van Ness Avenue near Sacramento Street. The house, with a steep French-style mansard roof and an iron frame with stone exterior walls, was thought to be fireproof but was completely gutted by fire when a maid left a third floor window open during the 1906 fire. The building was later restored and used as a private school until its demolition in 1928.

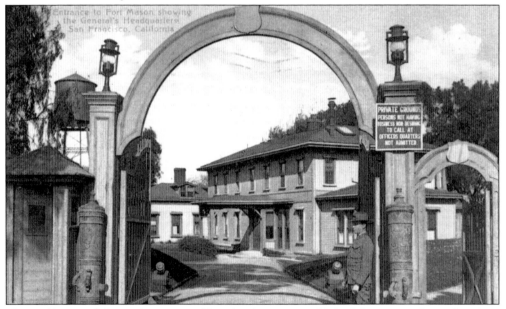

The residence of the senior army officer in the western United States was located at Fort Mason. A sentry stood watch at the gate and denied access to anyone not having business with the general. Two 17th-century Spanish canons provided curb appeal for the Italianate mansion, which came to be known as McDowell Hall, after its first military occupant, Maj. Gen. Irvin McDowell. During the 1906 fire, the building served as headquarters for the military and municipal officials in their efforts to stop the destruction.

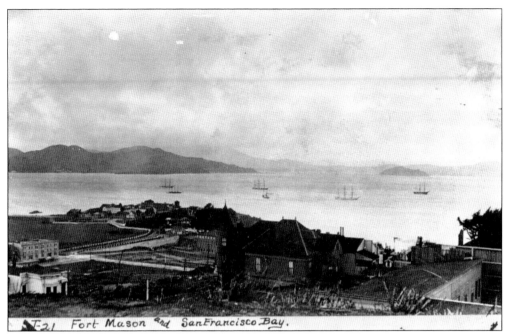

This is Fort Mason and San Francisco Bay, as viewed from Russian Hill. The U.S. Army took formal possession of the federal lands known as Black Point in 1863 to establish a gun battery to protect the city from possible Confederate raiders. The post was named Fort Mason in 1882 in honor of former California military governor Col. Richard Barnes Mason.

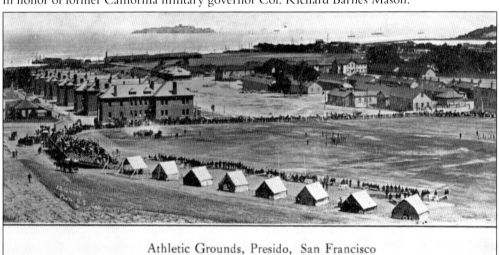

Athletic Grounds, Presido, San Francisco

This photograph by J. D. Givens shows the Presidio's athletic grounds, the main post area. Located on 1,480 acres in the northwest corner of San Francisco, the Presidio grew from the original Spanish outpost established in 1776. The large brick barracks on the left side of the picture were built in 1897. Each of the barracks could comfortably house a company of men in each of its two wings.

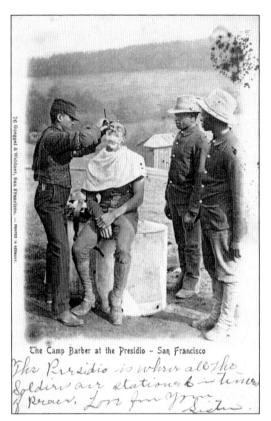

The Camp Barber at the Presidio - San Francisco

The Presidio is where all the Soldiers are stationed in times of peace. Love from your Sister.

An African American soldier is getting a shave and haircut from the camp barber at the Presidio in this Goeggel and Weidner postcard, mailed in 1904 with the message, "The Presidio is where all the soldiers are stationed in times of peace."

William Randolph Hearst published this postcard of a military parade on Market Street, mailed just three weeks before the 1906 earthquake and fire. The building in the center rear was the 19-story Claus Spreckels Building; for a decade, it was the tallest building in San Francisco. Remodeled in 1940, the landmark building still stands today as the deco-inspired Central Tower.

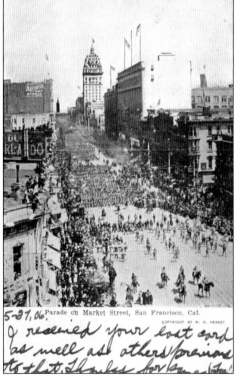

Parade on Market Street, San Francisco, Cal.

I received your last card as well as others previous to that. Thanks for [...]

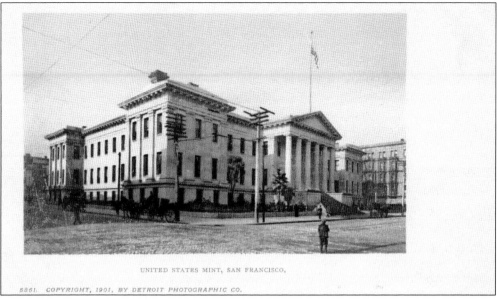

UNITED STATES MINT, SAN FRANCISCO.

5861. COPYRIGHT, 1901, BY DETROIT PHOTOGRAPHIC CO.

The U.S. Mint was featured on a Detroit Photographic Company card. Michigan's Detroit Photographic Company sent out teams of photographers across the United States to provide pictures for their postcards. Designed by A. B. Mullett and completed in 1874, the mint was a massive brick, granite, and sandstone structure in the Federal Baroque-Classical Revival-style of architecture. The restored "Old Mint" is now the home of the San Francisco Museum and Historical Society.

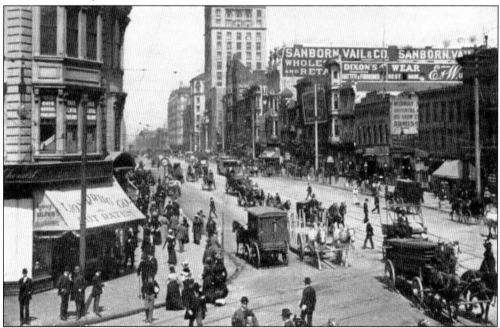

Many of the buildings did not exceed more than three or four stories in height along the city's main commercial thoroughfare in this early-20th-century view of Market Street. Pedestrians had to watch their step, as horse-drawn wagons and carriages ruled the road. Cable cars were the primary means of public transportation.

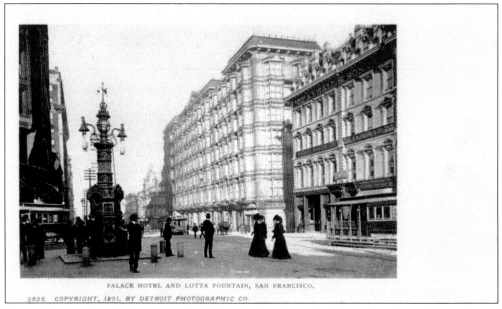

One of the grandest 19th-century buildings in America, the Palace Hotel, was the project of financier William Ralston. The Palace stood seven stories tall, had 755 rooms, and covered an entire city block. Hotel management claimed the private toilets for each room were virtually noiseless. Lotta's Fountain, a gift to the city from entertainer Lotta Crabtree, appears on the left side of this Detroit private mailing card view.

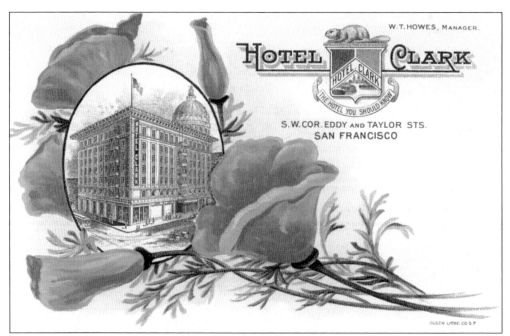

"The Hotel You Should Know," the Hotel Clark, was located at Eddy and Taylor Streets. It was seven stories high and not nearly as grand as the Palace Hotel, but outshone the more prominent building on this exquisitely designed postcard published by the Olsen Lithograph Company, featuring the Clark surrounded by California poppies.

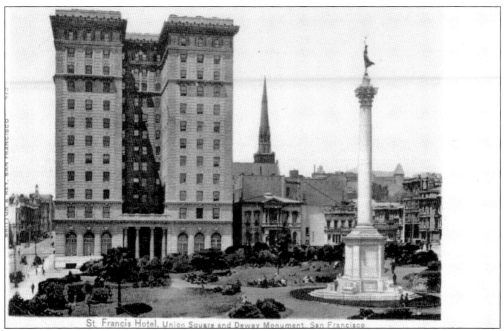

St. Francis Hotel, Union Square and Dewey Monument, San Francisco

The St. Francis Hotel opened in 1904. It consisted of two wings in a Renaissance–Baroque style with a granite base, gray Colusa sandstone walls, and marble Ionic columns. The hotel fronted on Union Square, where guests could view the 97-foot-high Dewey Monument, commemorating the victory of the American navy at Manila Bay. Sculptor Robert Ingersoll Aitken provided a bronze statue of *Victory*, a female armed with a trident and a wreath. Alma de Bretteville was the model for *Victory*.

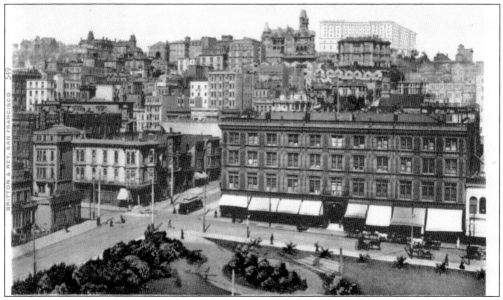

This Britton and Rey *c.* 1905 view shows the northwest corner of Union Square. Fine shops appear along Post Street, with a cable car ready to begin its climb up Powell Street to Nob Hill. The Hopkins Art Institute, with its high tower, stands at the crest of the hill, across from the newly built white granite Fairmount Hotel.

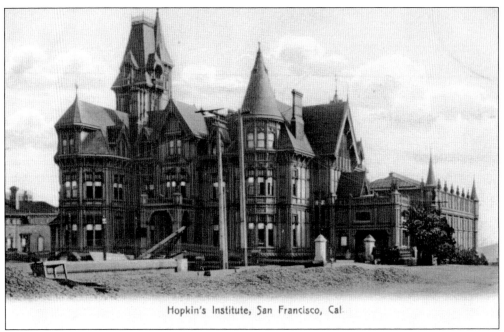

Hopkin's Institute, San Francisco, Cal.

The Mark Hopkins mansion was a turreted Victorian monument of redwood, painted the color of gray stone. Historian Charles Lockwood wrote that the Nob Hill mansions were built to be symbols of their owner's wealth, success, and personal worth. Unfortunately for railroad magnate Mark Hopkins, he died before the mansion was completed. By the time San Francisco publisher Fritz Muller produced this view, the California School of Design had inherited the mansion to use as an art institute.

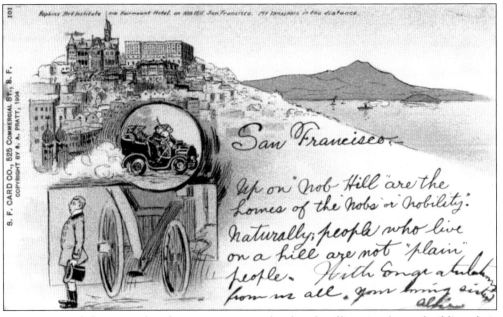

It was not until the 1870s that the new mining and railroad millionaires began building their mansions on Nob Hill. The San Francisco Card Company produced this comic postcard for S. A. Pratt in 1904. Part of a series of cards, Pratt defined San Francisco with humorous puns.

Nob Hill was too steep for horse-drawn omnibuses or street railroad cars. Without public transportation, the hill remained vacant until the 1870s. The beginning of cable car service on Clay Street in 1873 and California Street in 1878 made Nob Hill accessible and fashionable. This Goeggel and Weidner card shows the cable cars climbing the California Street hill past St. Mary's Catholic Church and the first Grace Cathedral, up to the Stanford Mansion near the crest.

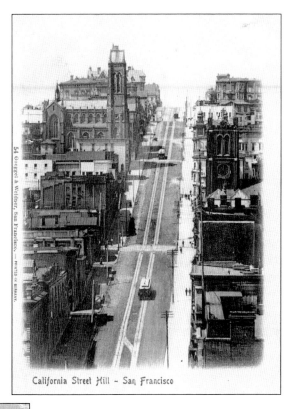

California Street Hill - San Francisco

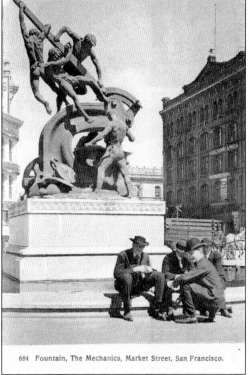

684 Fountain, The Mechanics, Market Street, San Francisco.

One of San Francisco's finest works of art, *The Mechanics* monument, also known as the Donahue Memorial Fountain, is located at the intersection of Market, Battery, and Bush Streets. The bold sculpture was created by Douglas Tilden and commemorates the five stages of one man's life, with nude brawny artisans forcing a plate of metal through a huge mechanical punch. Originally centered on a fountain, the monument has always been a gathering place.

31

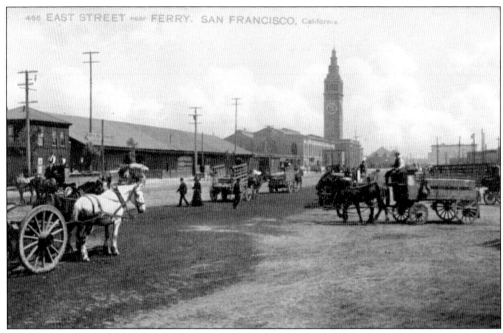

East Street (later renamed the Embarcadero) was the San Francisco waterfront's main street. Draymen arrive on horse-drawn wagons to load and unload ships in port. The Ferry Building appears in the background of this Charles Weidner postcard. *Chronicle* columnist Robert O'Brien wrote, "if the Embarcadero has a soul, it's shaped something like the Ferry Building."

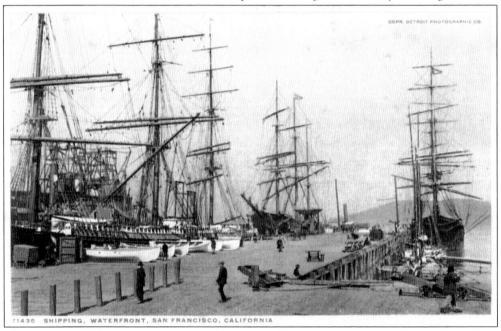

COPR. DETROIT PHOTOGRAPHIC CO.

71435 SHIPPING, WATERFRONT, SAN FRANCISCO, CALIFORNIA

The Detroit Publishing Company printed this view of the San Francisco waterfront. Throughout the 19th century, into the early 20th century, sailing ships continued to cast anchor at San Francisco docks. The fore-and-aft-rigged ships carried passengers, mail, and all types of cargo from Asia, South America, and all along the Pacific Coast.

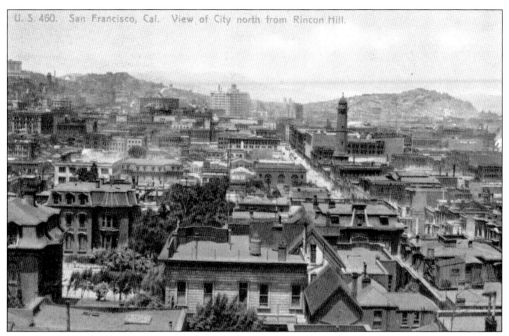

A view of the city, looking northwest from Rincon Hill, shows an eclectic array of architecture. Undeveloped land in the background shows the city still has room for growth. The 1900 federal census counted 342,782 residents of San Francisco. That same year, the board of supervisors voted to prohibit the burial of dead within the county limits after August 1, 1901. Only the National Cemetery in the Presidio would be exempt.

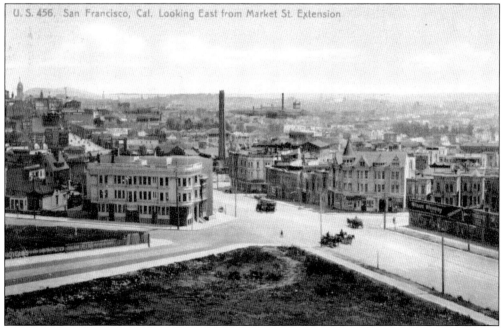

This is a pre-1906-earthquake view of the quiet intersection of Market, Hermann, and Laguna Streets. Upper Market Street was a residential area populated by a mix of Scandinavians, Germans, Irish, and many other nationalities.

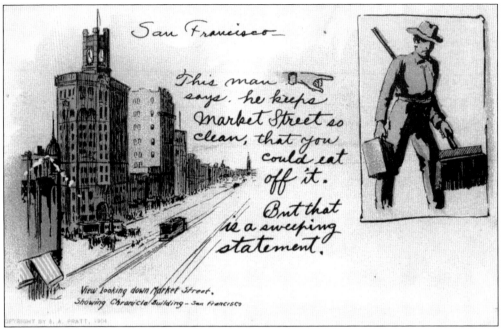

An S. A. Pratt San Francisco comic postcard is illustrated with a view looking down Market Street and a San Francisco street sweeper. The caption puns that the man keeps Market Street so clean that one could eat off it. But that is a sweeping statement.

Richard Berendt produced this panoramic bird's-eye-view postcard of San Francisco in the days preceding the 1906 earthquake. The Speckels Call Building at Third and Market Streets stands out as a landmark along with the Chronicle Building and Mutual Savings Building. The domed towers of Temple Emanu-El on Sutter Street appear on the lower right side of the card.

Three

THE 1906 EARTHQUAKE AND FIRE

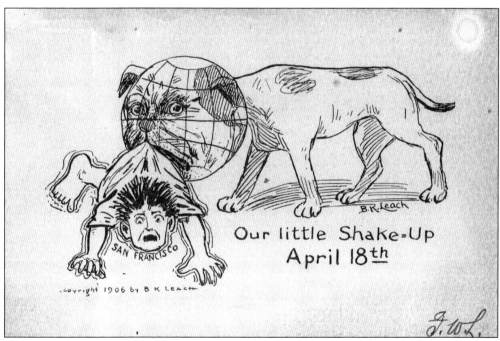

At 5:12 a.m. on April 18, 1906, San Franciscans were abruptly awaken by a violent earthquake lasting about one minute, estimated to have been at a seismic magnitude of 7.8 on the Richter scale. While the earthquake and its aftershocks wreaked havoc and destruction, it was the fire that started shortly after the earthquake that caused the most damage. The fire lasted three days, destroying most of the northeastern corner of the city. Out of 521 city blocks, 508 blocks were destroyed. With a population of over 450,000, it was estimated that 200,000 inhabitants became refugees. Before the embers cooled, publishers had thousands of souvenir postcards available for sale. One artist, B. K. Leach, created a series of popular illustrations showing the disaster's effects on the city's residents.

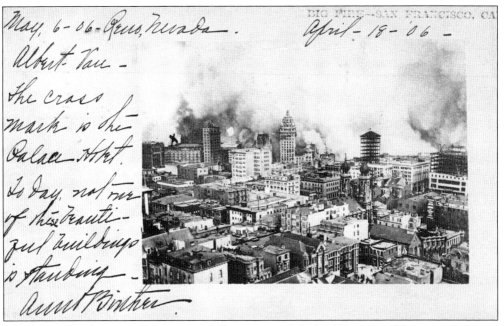

May, 6-06-Reno, Nevada--.

April - 18 - '06 -

Albert Van - The cross mark is the Palace Hotel. To day, not one of these beautiful buildings is standing - Aunt Bertha

This photographic postcard that notes, "The cross mark is the Palace Hotel," was mailed from Reno, Nevada, just 18 days after the earthquake. The message inaccurately claims, "not one of these beautiful buildings is still standing." Could the writer, Aunt Bertha, have been a refugee from San Francisco? The Southern Pacific Railroad provided free transportation to any refugee wishing to leave the city.

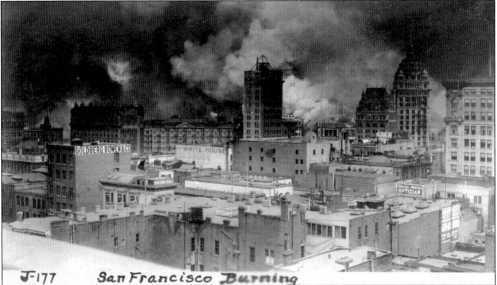

J-177 *San Francisco Burning*

San Francisco is burning; the fires started on both sides of Market Street and, within three hours, made a continuous line of flame from north of Market Street, along the waterfront, to south of Market Street, and along Mission Street to beyond Third Street. The fire continued spreading to the southwest. This real photo postcard shows the business district as the fire continued to spread. Note most of the buildings appear to have little apparent damage from the earthquake itself.

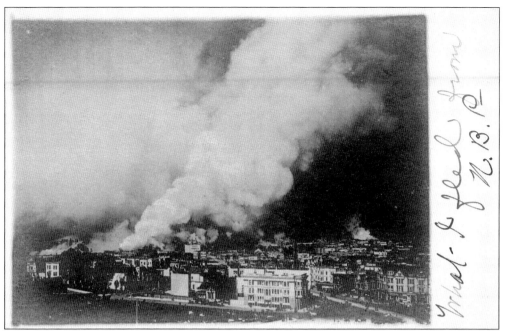

"What I fled from," reads the brief message from a writer known only by the initials N. B. P. This photographic postcard shows the same buildings and the intersection of Market and Laguna Streets, which appears on the earlier view on page 35. Fortunately for the large, white building and its neighbors, the fire would be stopped just across the street.

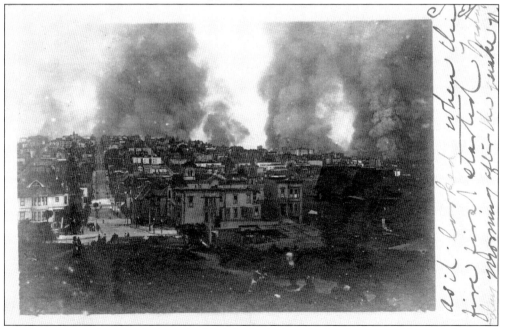

Another message from N. B. P. reads, "As it looked when the fire first started." Firefighters had only a small amount of water to try to put out the quickly spreading fires. There were no signs of panic among the refugees, as men, women, and children trudged over the city's hills to safety, carrying handfuls of possessions or standing silently watching their city being destroyed.

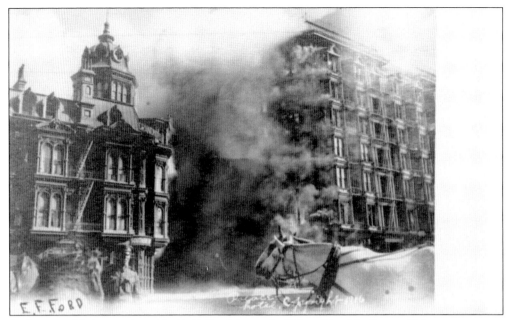

A photographic image signed by E. F. Ford shows the Palace Hotel in flames. Fifty-two separate fires were counted on April 18. These gradually merged into two conflagrations, one north of Market Street and one south of Market. The Palace Hotel had its own water supply derived from an underground artesian well. The hotel was protected from the fire by this water source until the well was pumped dry.

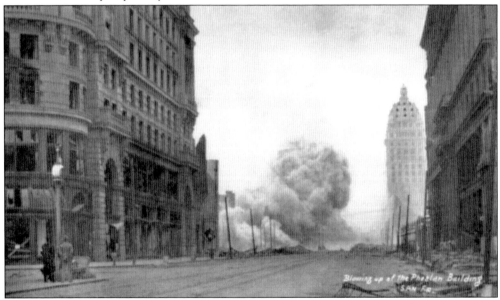

The city fire department requested authorization to dynamite buildings to create a firebreak. Mayor Eugene Schmitz, after conferring with superior court judge George Cabaniss on the legality of destroying private property, authorized the use of dynamite and requested that soldiers assist the firefighters. Artillerymen, trained in the use of canon shells, but inexperienced in the use of black powder and dynamite, set the charges, including the "Blowing up of the Phelan Building."

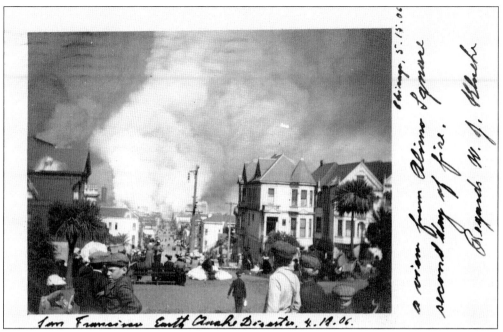

"San Francisco Earth Quake Disaster" features a view from Alamo Square on the second day of the fire. San Franciscans unaware of the damage to their stoves and chimneys started using them, causing a third major fire to erupt in the Hayes Valley District. The first night, refugees had expected to return to their homes and took very little with them; most slept in public parks, squares, and the city's military posts.

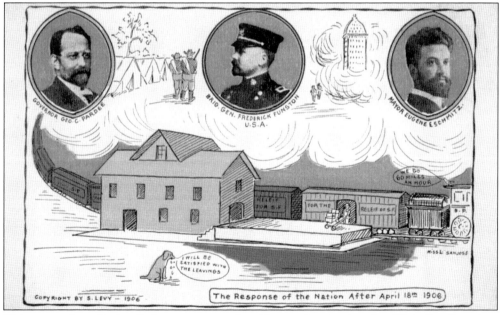

This postcard credited to S. Levy was part of an illustrated series showing life in San Francisco in the weeks following the disaster. The response of the nation is shown with the arrival of a train filled with relief supplies. Pictured on the card are the leaders of the efforts to save the city, Gov. George C. Pardee, Brig. Gen. Frederick Funston, and Mayor Eugene E. Schmitz.

PROCLAMATION
BY THE MAYOR

The Federal Troops, the members of the Regular Police Force, and all Special Police Officers have been authorized to KILL any and all persons found engaged in looting or in the commission of any other crime.

I have directed all the Gas and Electric Lighting Companies not to turn on Gas or Electricity until I order them to do so; you may therefor expect the city to remain in darkness for an indefinite time.

I request all citizens to remain at home from darkness until daylight of every night until order is restored.

I Warn all citizens of the danger of fire from damaged or destroyed chimneys, broken or leaking gas pipes or fixtures, or any like cause.

E. E. SCHMITZ, Mayor.
Dated, April 18, 1906.

9 If this Proclamation had not been posted, anarchy would have prevailed in San Francisco.

Mayor Schmitz's controversial proclamation was printed on fliers posted around the city and later appeared on a postcard. The mayor authorized federal troops and police officers to kill anyone engaged in looting. The caption of the card notes, "If this proclamation had not been posted, anarchy would have prevailed in San Francisco." There was not a single instance of a person being shot by regular troops. There were two men that were shot by state militia, and one citizen was killed by a self-constituted group of paramilitary vigilantes.

This souvenir postcard shows the famous April 19, 1906, *Call-Chronicle-Examiner* newspaper, which came about when the city's newspapers, still reeling from the disaster, consolidated their efforts in a single jointly published issue. A view of the severely damaged city hall is artistically illustrated in the center of the historic newspaper. The postcard was printed in Switzerland for Victor W. Bauer of San Francisco.

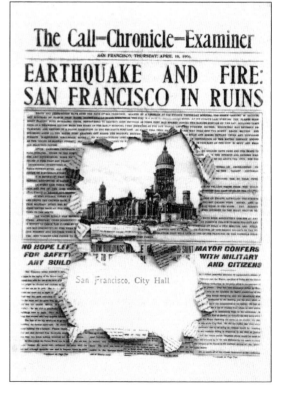

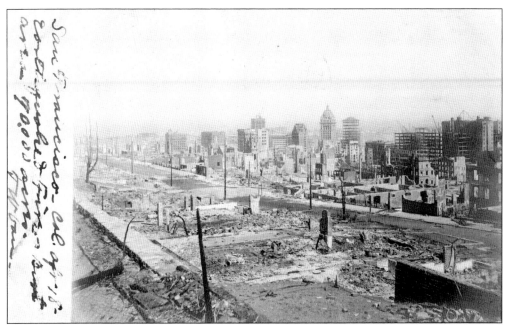

Despite the dynamiting to create firebreaks, it was not until rains came on April 22 that the fire stopped spreading. The sender of this photographic postcard, mailed in June 1906, notes the burnt area was 70,000 acres. The official reports stated that 4.7 square miles of the city were destroyed.

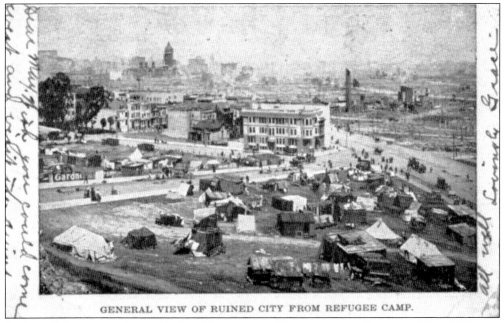

GENERAL VIEW OF RUINED CITY FROM REFUGEE CAMP.

A view of the intersection at Market, Hermann, and Laguna Streets (see pages 33 and 37) now shows a temporary refugee camp on the sloping hillside. All that remains on the south side of Market Street is rubble. The buildings on Laguna Street survived, including the large white building, which still stands today. The sender of this postcard, mailed in June 1906, writes, "Wish you could come west and visit the ruins."

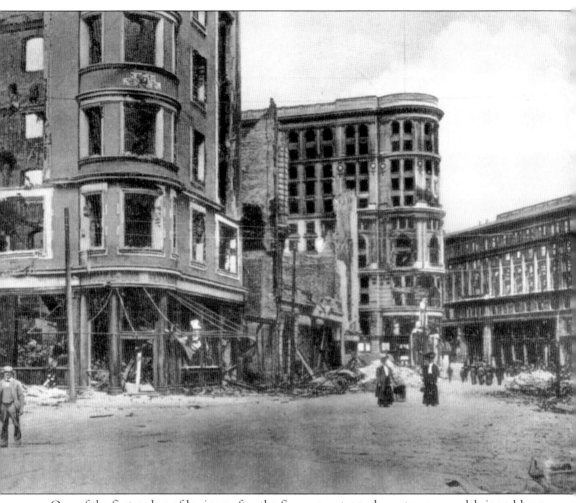

One of the first orders of business after the fires were stopped was to remove debris and keep the streets clear in the damaged areas, but people soon began walking through the city, as seen in this view looking down Ellis Street from Mason Street, showing the ruins of the Poodle Dog Restaurant, Flood Building, and the Emporium Department Store on Market Street. The card was printed in the unusual size of 5-inch-by-7-inch by M. Reider, a publisher located in Los Angeles and Dresden.

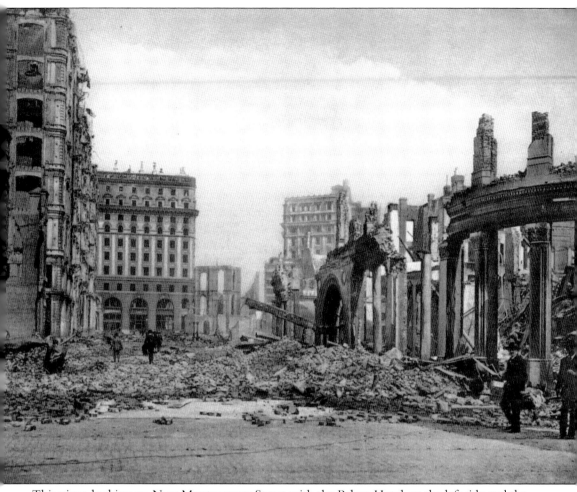

This view, looking up New Montgomery Street with the Palace Hotel on the left side and the Crocker Woolworth Bank on the right side, is from the series published by M. Rieder. Author Jack London, who was born a few blocks from the location pictured on this card, described walking through the city streets in the days following the fire; he found them deserted and littered with abandoned trunks and possessions.

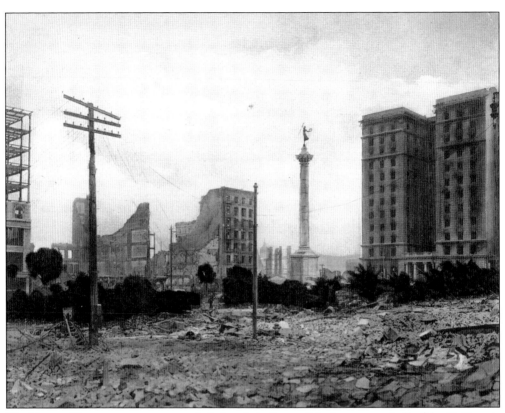

The Dewey Victory monument stands forlornly in front of the burnt-out shell of the St. Francis Hotel. The official count of casualties in 1906 numbered 498 known and unknown dead. In the 1980s, librarian Gladys Hansen found that injuries eventually resulting in death were not counted. Dr. Donald Cheu developed a new standard for defining earthquake deaths caused within one year by falling objects, unsanitary conditions, and suicides, which brought the death toll count to over 3,000.

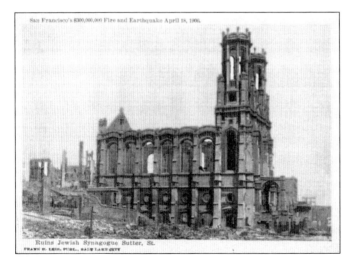

The ruins of the Jewish synagogue, Temple Emanu-El, once a San Francisco landmark, is shown in this postcard published by Frank H. Leib of Salt Lake City. A predominately German congregation had the Sutter Street synagogue built in 1864. The damaged temple was rebuilt in 1907. The medical building at 450 Sutter Street was built on the site after the congregation moved to a new location on Arguello Boulevard in 1926.

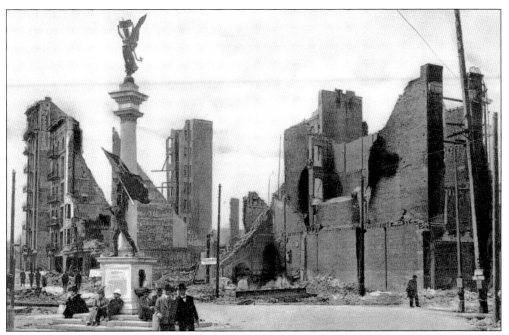

Douglas Tilden's *Native Sons* monument, commemorating California's admission into the Union in 1850, stands amongst the ruins on the corner of Market, Turk, and Mason Streets. The caption on this Rieder card states, "the monument still proclaims the spirit of progress, and Victory and is one of the few objects of value to be spared from the ravenous flames."

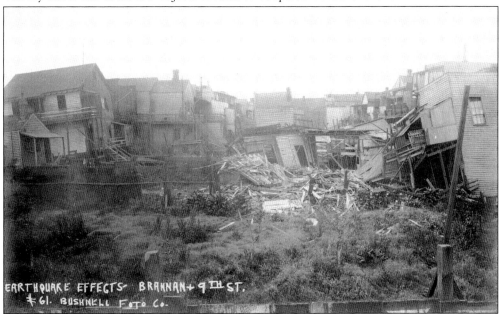

The South of Market working-class area at Ninth and Brannan Streets is shown on this Bushnell Foto Company postcard. While the neighborhood was spared from fire, many wood frame buildings were severely damaged by the earthquake. One victim identified only as Mrs. O'Toole, who lived on Ninth Street, suffocated when a large framed picture fell on her. Mr. O'Toole carried his wife's body for several days until she was finally buried.

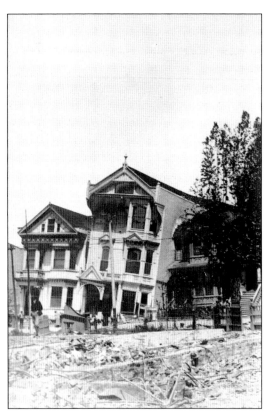

While most cards depict the ruins of prominent buildings downtown, the damage was significant in the residential neighborhoods, as seen in this photographic postcard featuring two large residential buildings at Seventeenth and Howard Streets knocked off their foundations. The only thing keeping the center building from completely collapsing is the smaller building to its right behind the tree.

The Cow Hollow neighborhood, while located on good solid bedrock, experienced damage, as seen in this view of a ruptured Union Street looking east from Pierce Street. The message from Aunt Anna states, "Glad I was not there." The card was published by Durham Press in Bridgeport, Connecticut, from an Underwood and Underwood stereograph. Vendors throughout the country provided views of the damaged city.

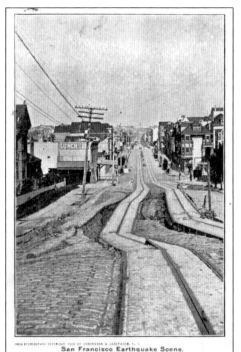

San Francisco Earthquake Scene.
Destruction by Earthquake on Union St., East from Pierce.

Glad, was not there. Emma
Published by The Dunham Press, Bridgeport, Conn.

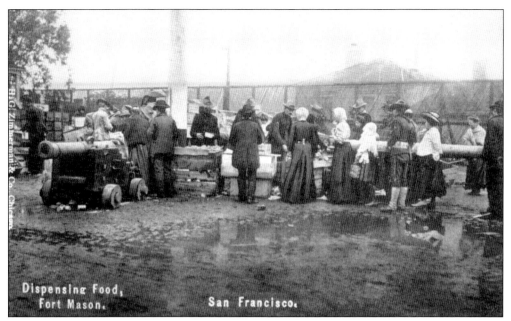

Dispensing Food,
Fort Mason. San Francisco.

Food had to be provided to the refugees. Hot meal kitchens were quickly set up and initially were supervised by the U.S. Army. This H. G. Zimmerman view shows soldiers dispensing food at Fort Mason. Three civilian contractors were hired to distribute food. By June 1906, there were 27 relief kitchens in the city. Between May and October 1906, there were 1,474,963 free meals provided.

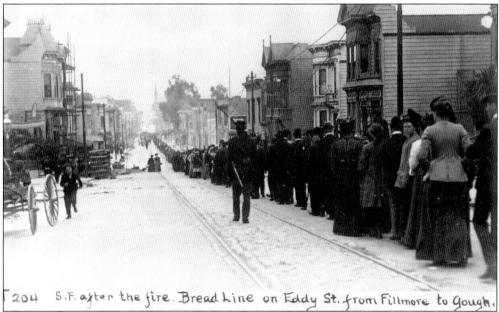

204 S.F. after the fire. Bread Line on Eddy St. from Fillmore to Gough.

The bread line on Eddy Street from Fillmore to Gough Streets was 5 blocks long. One initial problem was the distribution of sacks of flour to people who had no facilities for baking. This was resolved when donated flour was given to bakeries to prepare loaves of bread for distribution. Sometimes entire families, plus the family cook, lined up in the bread line to get as many loaves as possible.

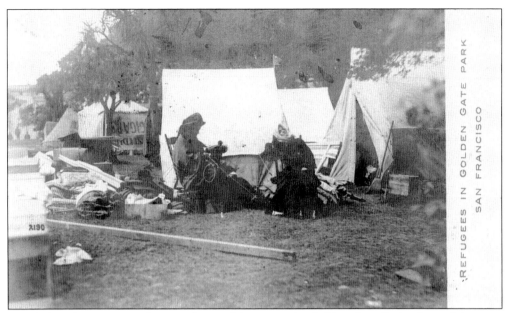

Two lady refugees sit on chairs in front of their tents in Golden Gate Park. General Funston had requested the war department send tents to the stricken city for use by the refugees. Under the direction of Lt. Col. George Torney, 26 medical dispensaries and a field hospital were set up to provide free medical care for thousands of civilians, mostly women and children. Lieutenant Colonel Torney was later selected to head the city health commission.

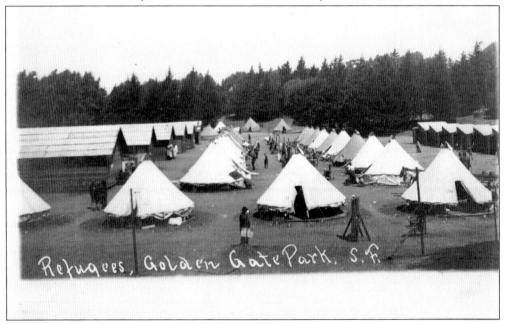

Refugees, Golden Gate Park, S.F.

A refugee camp in Golden Gate Park featured conical shaped Sibley tents that were 18 feet in diameter. There were 18 large barracks, each with 16 two-room apartments. The three large refugee camps in the park distressed park superintendent John McLaren, who commented the camps were "pest holes breeding a pauper class and a menace to the welfare of the community." The last park camp at Speedway Meadow remained open until late August 1907.

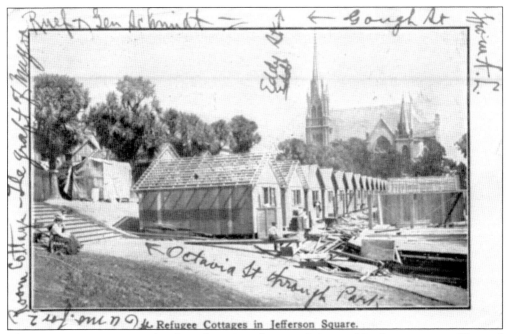

Refugee Cottages in Jefferson Square.

The *San Francisco Examiner* distributed a series of postcards inserted in the newspaper. Pictured are refugee cottages under construction in Jefferson Square, along with comments noted in the margin about a $6 rent for the cottages and the graft of Mayor Schmitz. Initiated by Maj. Gen. Adolphus W. Greely, the cottages were built by union carpenters as a joint effort of the San Francisco Relief Corporation, the city park superintendent, and the army.

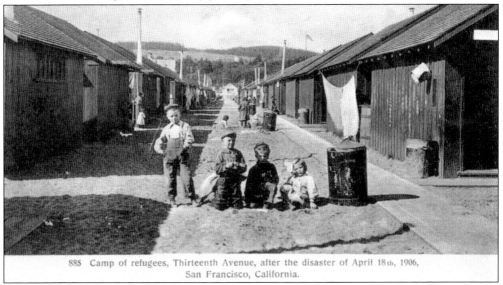

885 Camp of refugees, Thirteenth Avenue, after the disaster of April 18th, 1906, San Francisco, California.

Twenty-nine official refugee camps were established, including 13 camps where cottages were constructed. This Cardinell-Vincent postcard shows children at the camp on Thirteenth Avenue (later renamed Funston Avenue). The cottages ranged in size from 10 feet by 14 feet to 16 feet by 18 feet. They had fir floors, cedar shingle roofs, and redwood walls painted forest green. Occupants paid $2 a month towards eventual purchase for $50 and could also rent wood burning stoves. The last refugee camp at Lobos Square closed in July 1908.

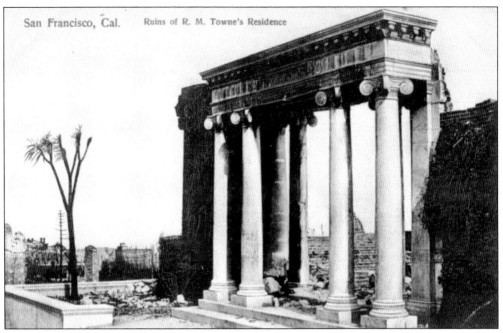

The portico was all that remained of the Nob Hill residence of A. N. Towne (misidentified as R. M. Towne on this Pacific Novelty Company postcard). In 1909, the classic columns were presented as gift to the city and permanently placed in Golden Gate Park overlooking Lloyd Lake. Known as the "Portals of the Past," they became a monument to both the victims and survivors of the 1906 disaster.

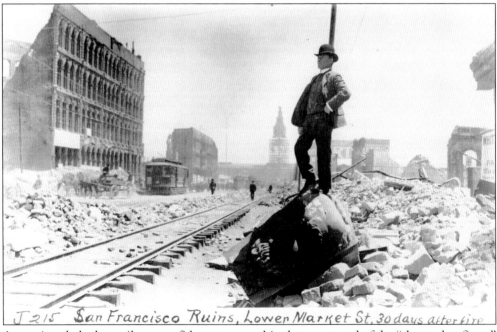

J 215 San Francisco Ruins, Lower Market St. 30 days after fire

A man in a derby hat strikes a confident pose, on this photo postcard of the "damnedest finest" ruins along lower Market Street near Davis Street, 30 days after the fire. Rubble has been cleared off the track, and the streetcars are ready to run.

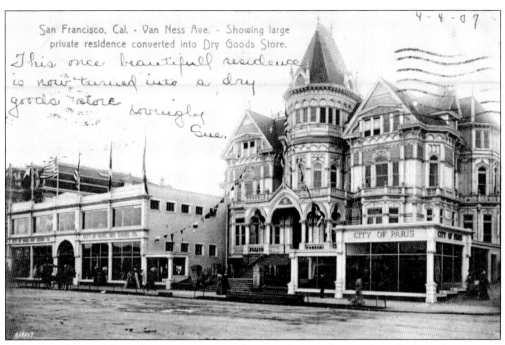

San Francisco, Cal. - Van Ness Ave. - Showing large
private residence converted into Dry Goods Store.

This once beautifull residence is now turned into a dry goods store. Lovingly Sue.

"This once beautiful residence is now turned into a dry goods store." Mailed nearly one year after the earthquake and fire, this Pacific Novelty card shows the temporary retail district along Van Ness Avenue, with a surviving residence on the west side of the street converted into a retail store, City of Paris.

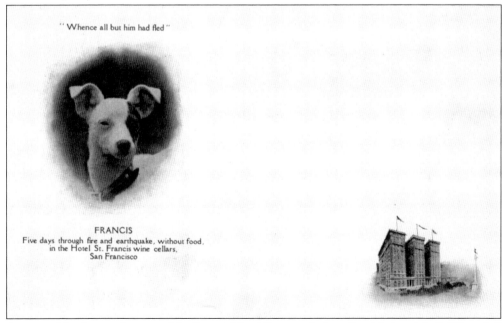

" Whence all but him had fled "

FRANCIS
Five days through fire and earthquake, without food,
in the Hotel St. Francis wine cellars,
San Francisco

A postcard for the newly restored St. Francis Hotel features the hotel's celebrity pit bull, "Francis," who loyally remained for five days through the earthquake and fire alone and without food or water in the hotel's wine cellars. Francis's image would appear on all of the cartoon postcards of B. K. Leach, and after the hotel reopened, guests would visit the wine cellar to meet Francis.

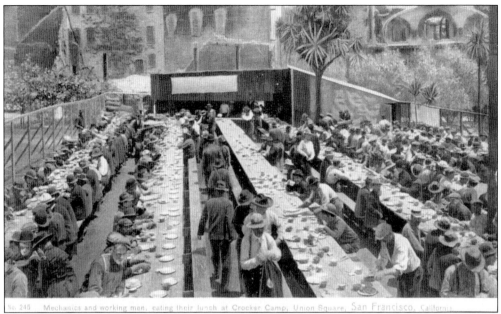

No. 245 Mechanics and working men, eating their lunch at Crocker Camp, Union Square, San Francisco, California.

Charles Weidner published this postcard showing mechanics and working men eating their lunch at Crocker Camp in Union Square. Within a few days of the disaster, San Franciscans with indomitable spirit began rebuilding their city. Within three years, much of the evidence of destruction downtown had been replaced with tall new steel frame buildings, testimony to the city's progress and the "can do" attitude of the times.

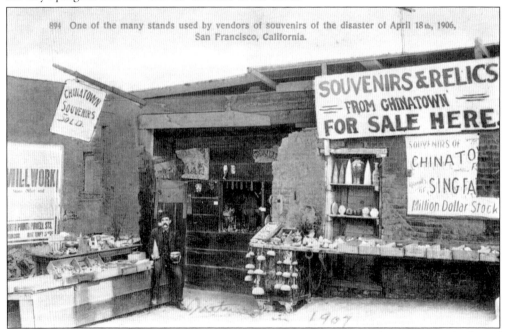

894 One of the many stands used by vendors of souvenirs of the disaster of April 18th, 1906, San Francisco, California.

A year after the earthquake, there were many stands used by vendors of souvenirs and relics of the disaster. The entrepreneur seen in this postcard has set up shop within a roofless, damaged building selling chinaware and bric-a-brac, much of it apparently from the Sing Fat Store in Chinatown.

Four

GREETINGS FROM
SAN FRANCISCO

The spirit of the city was captured on this Charles Weidner, large-letter greeting card with each letter in San Francisco filled in with a montage of municipal landmarks. The nine years following the earthquake and fire of 1906 was a period not only of recovery, but also of tremendous growth and development. It was the rebirth of a major American city. San Francisco's symbolic bird, the phoenix, was rising. It was also a period of political upheaval with the graft trials of political boss Abraham Ruef, Mayor Schmitz, and the entire board of supervisors. Local politics would be in a state of flux, with frequent changes at city hall. Between 1906 and 1915, there would be five different mayors. Added to the municipal mix were labor strikes, parades, and celebrations, providing a very interesting and dynamic era, often documented on thousands of postcards.

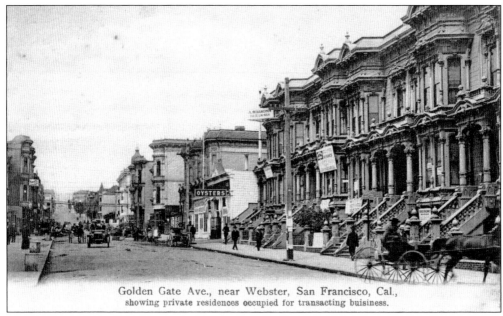

Golden Gate Ave., near Webster, San Francisco, Cal.,
showing private residences occupied for transacting buisiness.

Most of the city's Western Addition neighborhood escaped destruction. Relocated smaller businesses temporarily used the district's houses and flats, as seen in this I. Scheff and Brothers view of Golden Gate Avenue, near Webster Street, showing private residences occupied for transacting business. Note the automobile coming down the middle of street past the horse-drawn carriages.

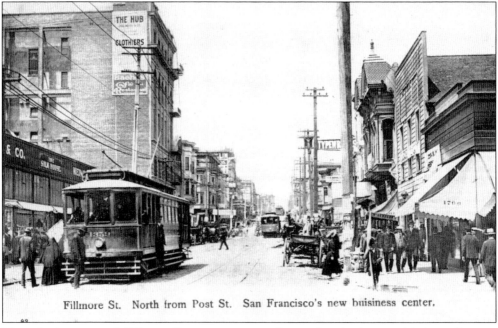

Fillmore St. North from Post St. San Francisco's new buisiness center.

Many businesses used Fillmore Street to temporarily conduct business, with its trolley car service running from Market Street to Broadway, Fillmore Street seemed like an ideal location as San Francisco's new business center, as seen in this I. Scheff and Brothers view of Fillmore Street looking north from Post Street.

"Morning Sol," a Pacific Novelty Company cartoon postcard by Gardner, shows a worker involved with the reconstruction of San Francisco. With the new high-rise buildings, the poem claimed, "We may soon be on speaking terms with the Sun!" This was a light-hearted image showing San Francisco's efforts to still be the leading metropolis on the Pacific Coast.

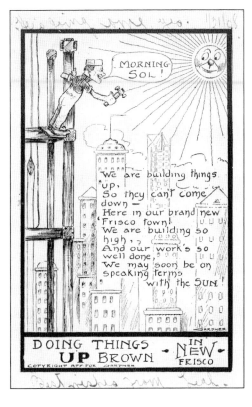

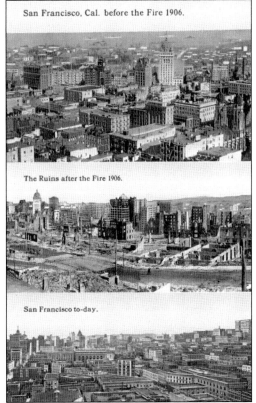

San Francisco, Cal. before the Fire 1906.

The Ruins after the Fire 1906.

San Francisco to-day.

How much the city recovered in two years can be seen in this Richard Behrendt postcard that shows three views of San Francisco. While the images were not taken from exactly the same location, they do give the viewer a look at how the city's downtown area looked before the fire, in ruins, and as it appeared after reconstruction. In the years following the earthquake, 9,800 new buildings were built with a value of $115,500,000.

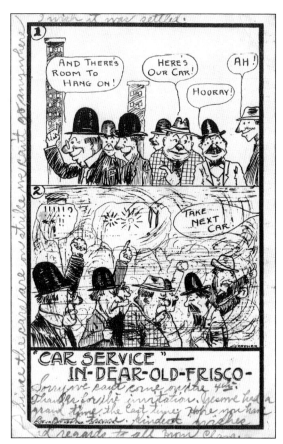

"Since the cars are on strike we can't go anywhere," says a note on this Gardner card. United Railroads owned most of the local streetcar lines in San Francisco. Carmen's Union Local 205 hoped to improve their working conditions with a 30¢ an hour wage increase and an eight-hour day. On May 5, 1907, the Carmen went on strike. United Railroads president Patrick Calhoun brought in guards and nonunion operators to run the cars. Strikers encouraged the public to boycott the streetcars.

This postcard cartoon by S. Levy was originally intended as a commentary on the after effects of the earthquake. The sender's comments reflect the situation of the strike: "Either this or walk." On May 6, 1907, the strike turned violent; mobs threw bricks and rocks, and both sides used guns. Sympathetic people paid a small fee to ride horse-drawn carts operated by union supporters.

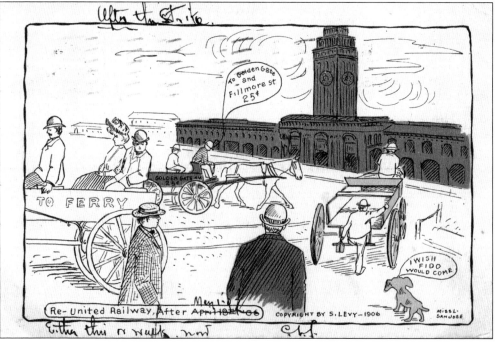

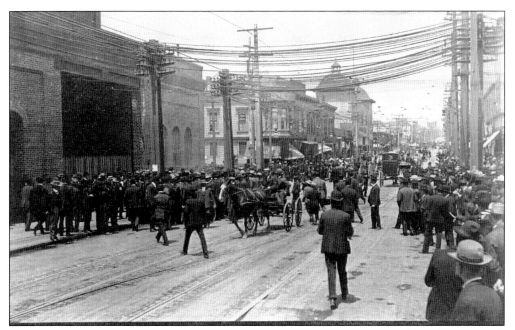

A photographic postcard shows the car men's strike in May 1907, outside the carbarn at Turk and Fillmore Streets. By the time the San Francisco Labor Council had endorsed the strike, United Railroad's daily passenger load had dropped 75 percent, and sporadic outbreaks of physical violence continued to occur.

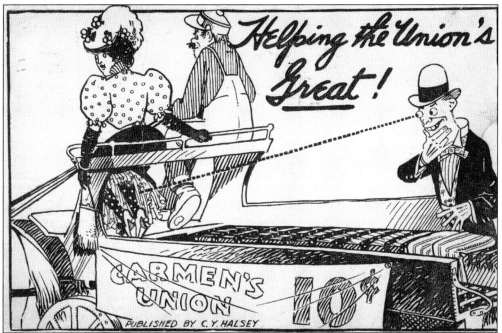

Despite the acrimony of the strike, cartoonist C. Y. Halsey's "Helping the Union's Great" card shows a mild bit of risqué humor. After the union ran out of strike funds, the strike was called off in March 1908. The violent strike ended with a total of six deaths and more than 250 injuries from both sides.

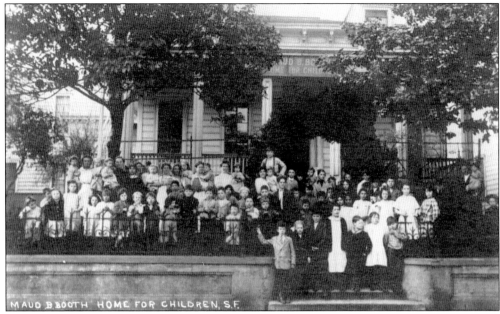

The Maud Booth Home for Children was located at 814 Shotwell Street and was established by philanthropist, evangelist, and Volunteers of America founder Maud Bellington Booth. She used a small fortune inherited from her father to help men and women in prison, operate soup kitchens, provide temporary shelters for needy individuals, and a children's home in San Francisco.

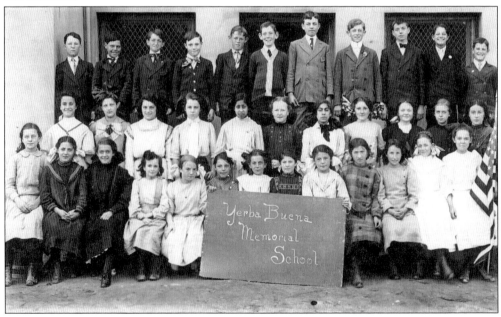

The Yerba Buena Memorial School was located in Cow Hollow at Greenwich and Webster Streets. In 1906, thirty San Francisco public schools were either destroyed or severely damaged by the earthquake and fire. The Yerba Buena School was built with money donated from children throughout the United States to the children of San Francisco. In this postcard, students pose for their class picture at Yerba Buena.

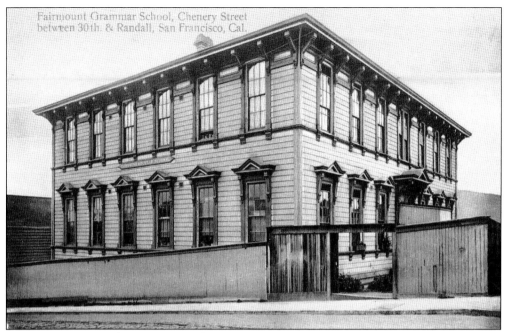

Richard Behrendt published a series of postcards of San Francisco public schools. The Fairmount Grammar School on Chenery Street, between Thirtieth and Randall Streets, was a wood frame building with 12 rooms. W. H. DeBell was the principal with grades first through eighth.

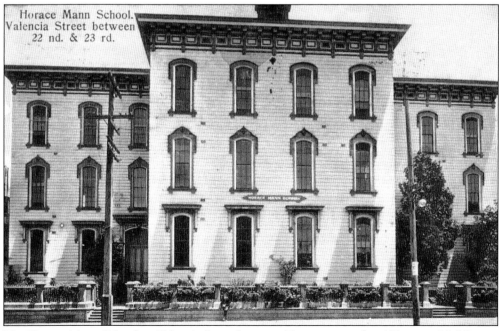

The Horace Mann School on Valencia Street between Twenty-second and Twenty-third Streets was a 20-room wood frame building. R. D. Faulkner was the principal with grades sixth through eighth. Evening classes were also provided at Horace Mann. The schools pictured on these postcards were typical of the elementary schools in San Francisco at this time.

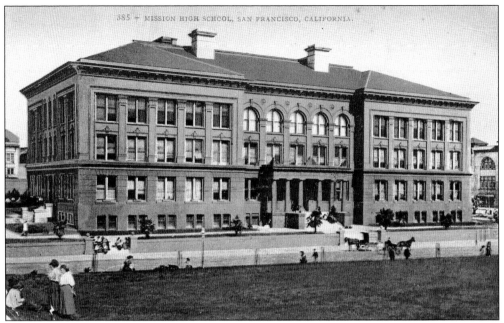

Mission High School was one of the city's five public high schools. Located at Eighteenth and Dolores Streets, the school survived the 1906 earthquake with severe damage. When the school reopened, W. O. Smith was principal with a faculty of 15 teachers of both commercial and academic subjects. The small building on the right is the Swedish Evangelical Church.

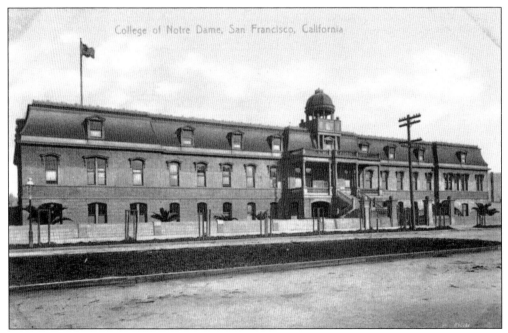

College of Notre Dame, San Francisco, California

The College of Notre Dame, pictured on this Charles Weidner postcard, was built in 1907 to replace an earlier building, which was destroyed by the 1906 fire. The building served as a Catholic preparatory school for girls. Today the building has been converted to 66 units of affordable residences for seniors.

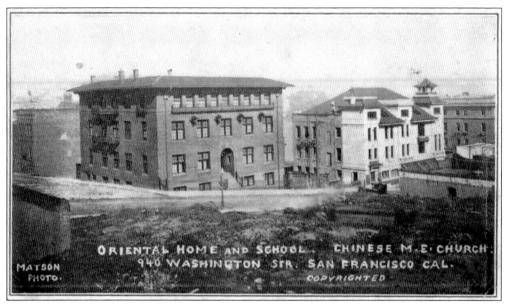

The Oriental Home and School of the Chinese Methodist Episcopal Church at 940 Washington Street was a brick building designed by architect Julia Morgan; it was completed in 1911. Replacing an earlier mission destroyed in 1906, the Mission Home sheltered Chinese children, mostly girls, and provided classes in language, Christian education, and vocational skills. Since the 1930s, the building has served as a residence for adult Chinese females and offers children's programs and family support services.

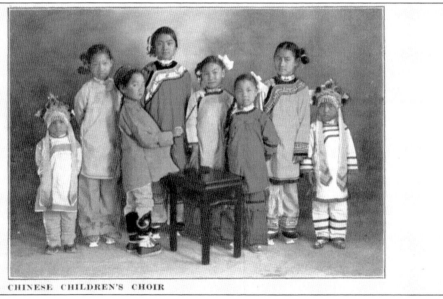

CHINESE CHILDREN'S CHOIR

The Chinese Children's Choir members were residents of the Oriental Home. The choir sang to raise funds for their new building. They appeared across the country, and in November 1908 sang at the White House for Pres. Theodore Roosevelt. According to research provided by Jeff Staley, the tallest girl is his wife Barbara's grandmother, Maud Lai. The children, pictured from left to right, are Ida Woo, Lydia, Bok Lum Wong, Maud, Mamie, Ruby Tsang, Pearl Tsang, and May Shen. Bok Lum Wong is the only boy in the group.

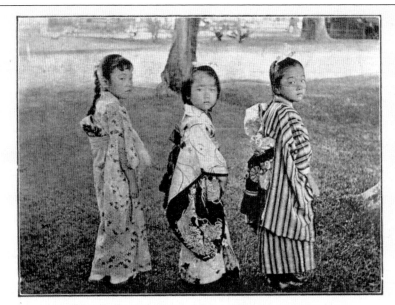

THREE LITTLE MAIDS, Japanese Home, San Francisco

San Francisco was the primary point of entry for immigrants from Japan and had a large Japanese community. This card, "Three Little Maids, Japanese Home, San Francisco," shows girls wearing traditional kimonos. Racial animosity against the Japanese community reached new heights when the San Francisco School Board restricted Japanese students to a school established for Chinese students. When the Japanese government protested, Pres. Theodore Roosevelt negotiated a "gentlemen's agreement rescinding the city's policy in exchange for reductions in further immigration."

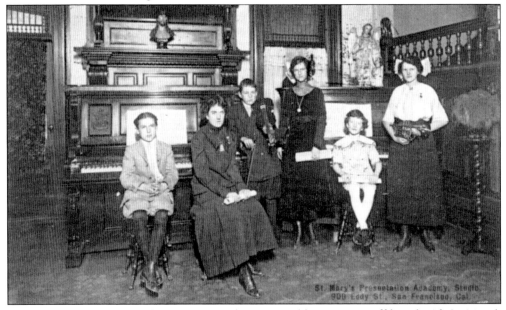

St. Mary's Presentation Academy Music Studio at 900 Eddy Street was affiliated with St. Mary's Cathedral and provided classical musical education for these students who appear ready to perform a recital.

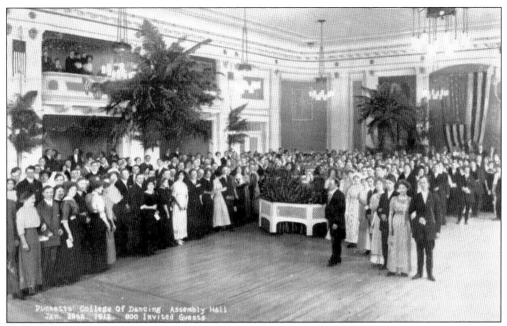

Puckett's College of Dancing, located at the Assembly Hall on 1268 Sutter Street, was the home of refined dancing. A large turnout could be expected for such monthly events as peanut parties with peanuts and favors for all, a Serpentine Battle, and an informal indoor picnic party. Puckett's advertised that it was always fun for all.

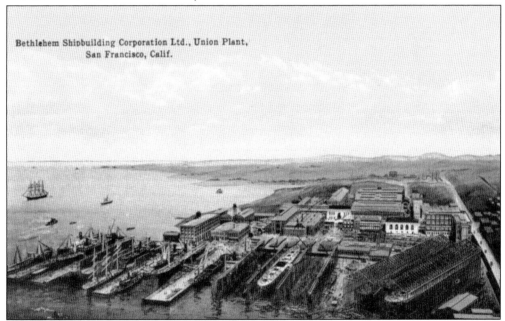

The West Coast yards of the Bethlehem Steel Company fronting on the Bay and Central Basin at Twentieth and Illinois Streets was pictured on this Cardinal-Vincent view card. Originally the Donahue family's Union Iron Works in the 1880s, they established San Francisco as a major ship building yard for war ships, including Admiral Dewey's flagship *Olympia*, the battleship *Oregon*, and the hospital ship *Solace*.

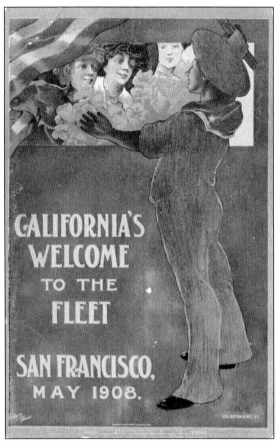

"California's Welcome to the Fleet, San Francisco, May 1908." The city played host to the U.S. Navy plus a half million visitors from throughout the West. The fleet commanded by Rear Admiral Robley D. "Fighting Bob" Evans was showing Pres. Theodore Roosevelt's "Big Stick" with a world cruise of 30 warships. On Telegraph Hill, a 50-foot-high welcome sign greeted the sailors. On May 7, a parade of over 7,500 sailors and marines marched in review through the city. While dignitaries feted the admiral at a reception at the St. Francis Hotel, junior officers and men probably enjoyed the German beers at The Louvre, "San Francisco's Leading Restaurant."

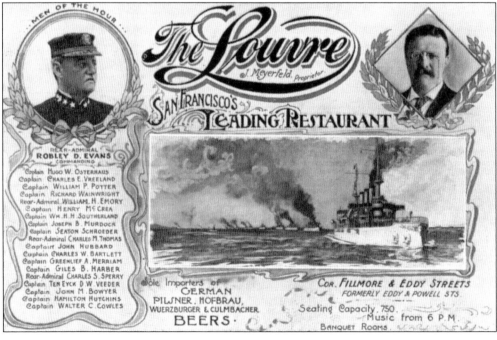

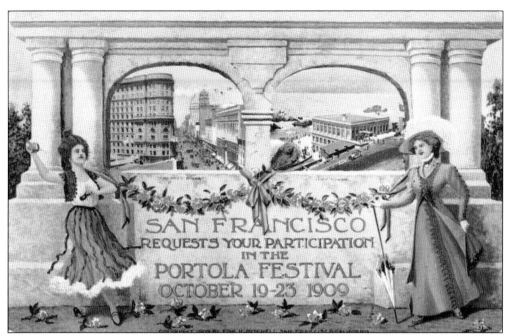

"San Francisco requests your participation in the Portola Festival, October 19–23, 1909." This Edward Mitchell postcard announces the five-day festival to officially celebrate the city's recovery from the 1906 disaster and commemorate the 140th anniversary of the discovery of San Francisco Bay by Don Gaspar de Portola.

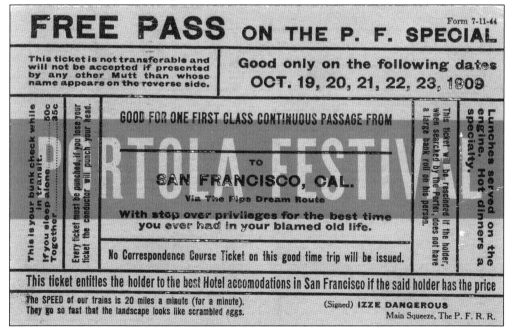

A "Free Pass on the P. F. Special," this postcard published by the Pacific Goldsmith Company in San Francisco promises fun and a good time at the Portola Festival. Events included a official landing of Portola at Pier 2, parades, receptions, football, a golf tournament, boxing, tennis, concerts, fireworks, and illuminated warships on the bay.

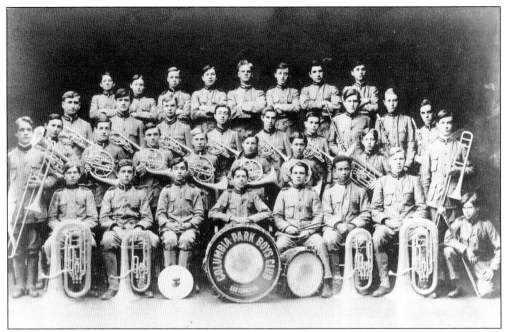

Among the Portola Festival participants were members of the Columbia Park Boys Club Band. The boys club was a south of market institution, located in an area severely damaged in 1906. With a wide array of instruments and spiffy uniforms, the band would perform at many San Francisco civic events.

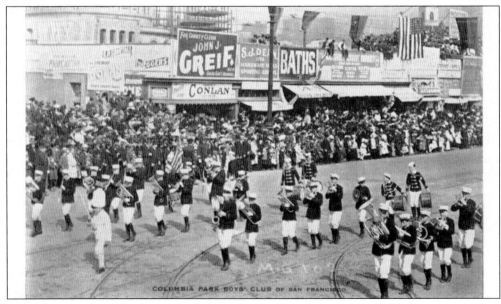

The sidewalks were crowded with spectators as the Columbia Park Boys Club Marching Band participated in the Portola Festival parade, marching down Market Street to Van Ness Avenue then turning back down Geary Boulevard to Union Square for the official ceremonies.

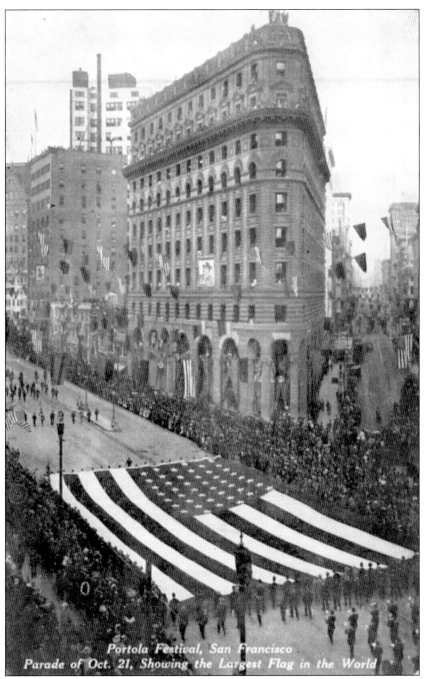

Portola Festival, San Francisco
Parade of Oct. 21, Showing the Largest Flag in the World

The highlight of the Portola Festival parade was this American flag, promoted as the largest flag in the world. It was carried by veterans of the Spanish-American War and escorted by Union veterans of the Civil War and their wives riding on floats. A military band provided the music. Parade marchers included politicians, the Native Sons and Daughters of the Golden West, lodges, fraternities and representatives of various nationalities. In addition to the giant "Old Glory," flags and banners were hung on every building along the route, as well as strings of lights outlining the Ferry Building, St. Francis Hotel, Humboldt Bank, and other large buildings.

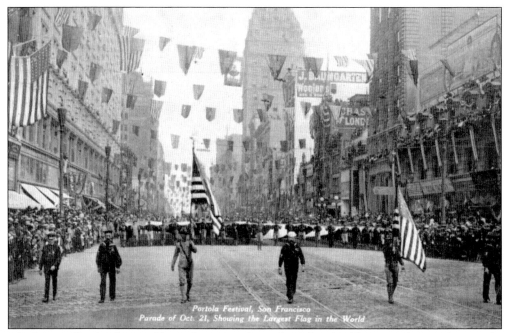

The largest flag in the world was best seen from the office building windows. This Pacific Novelty view shows the approaching flag coming up Market Street with a military honor guard representing each branch of the service. It would take the parade's 25,000 marchers three hours to pass in review.

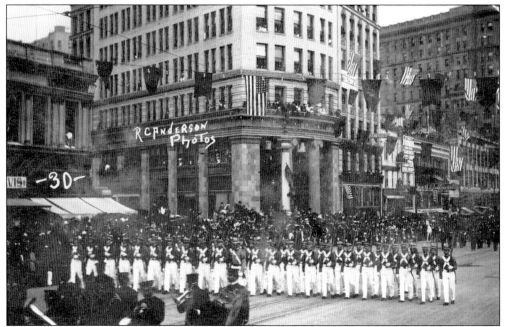

The California Grays march down Market Street in the Portola Festival parade in this R. C. Anderson photographic postcard. The California Grays were a civilian organization devoted to military drill. In San Francisco, the Grays Company was a well-trained organization rendering good service whenever a military escort or honor guard was needed.

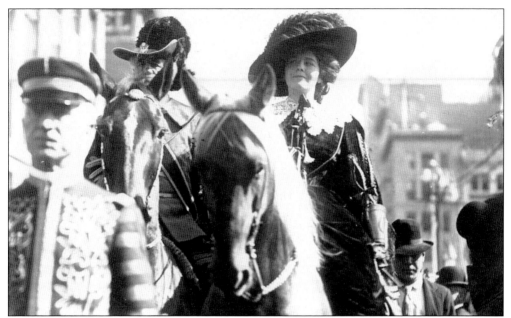

Nicolas Covarrubias of Santa Maria portrayed Don Gaspar de Portola and reigned as king over the festival. The 70-year-old Covarrubias was the son of a prominent Spanish merchant who came to California 11 years before the Gold Rush. Regal 22-year-old Vergilia Bogue was selected by a jury as the most beautiful woman in California and would reign as queen of the Portola Festival.

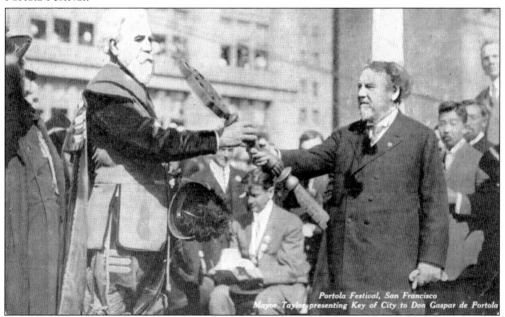

San Francisco mayor Edward Robeson Taylor presented the key to the city to Don Gaspar de Portola (Covarrubias). Mayor Taylor had a long and varied career as medical doctor, lawyer, educator, publisher, and poet. The successful completion of the five-day Portola Festival showed the nation that San Francisco was back in business and also a serious candidate for a future world's fair.

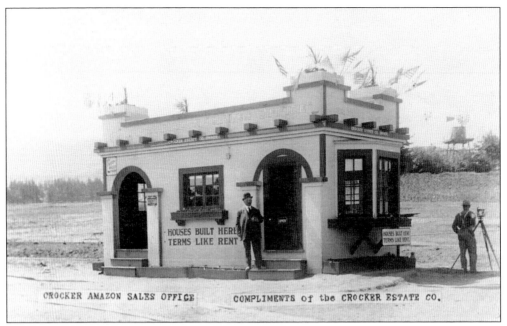

A photo postcard advertises the Crocker Amazon neighborhood development, which began on land holdings formerly owned by Charles Crocker near Amazon Street. In an effort to provide accessible home ownership, the sales offices promised, "Houses built here. Terms like rent."

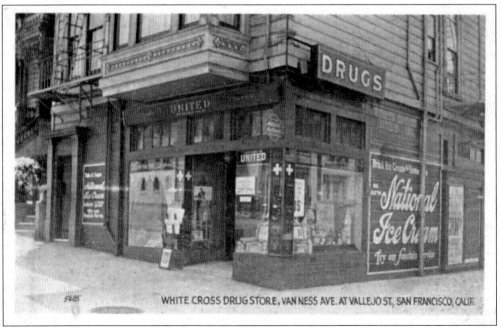

Across town, the White Cross Drugstore at 2221 Van Ness Avenue, on the corner of Vallejo Street, served the neighborhood's pharmaceutical needs advertising on the back of this photo postcard that "you'll always get personal attention and what you ask for."

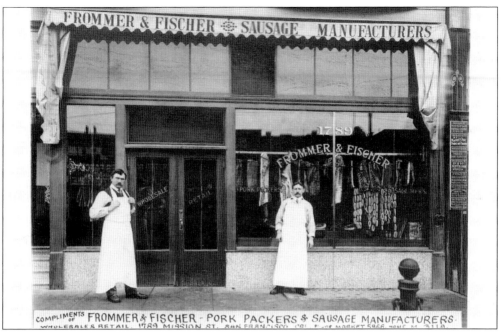

Frommer and Fischer, pork packers and sausage manufacturers, had photographer Charles Weidner create this advertising postcard for them standing in front of their wholesale and retail market at 1789 Mission Street. J. Fischer notes in his message that he has been very busy since his partner went to the country.

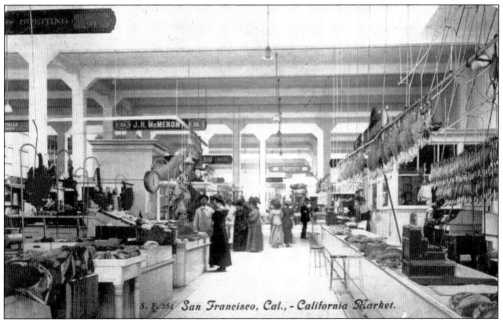

A interior view of the California Market, which ran through the block from Pine to California Streets between Montgomery and Kearney Streets, shows varieties of meat, fish, and fowl dressed and ready for sale as white-coated butchers wait on customers in the large, spacious meat market, shown on this Pacific Novelty Company postcard.

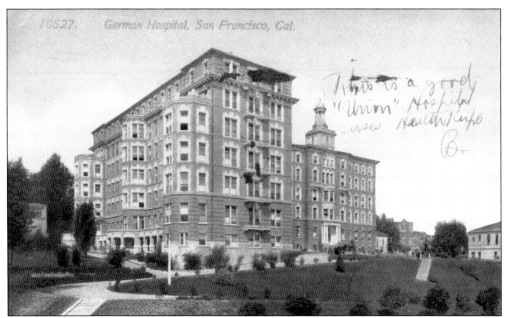

The message, "This is a good 'Union' Hospital," appears on the front of a postcard of the German Hospital (now Ralph K. Davies). The hospital served mostly working-class Germans from the nearby neighborhoods. Historian John McGloin estimated there were over 45,000 union members in San Francisco, nearly two-thirds of the union membership in the entire state of California in the years before World War I.

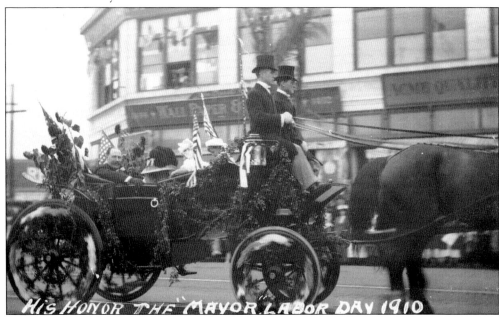

San Francisco was labor's city in 1910 when Patrick Henry McCarthy, an Ireland-born former carpenter and president of the Building Trades Council, was elected mayor on the Union Labor Party ticket. His honor the mayor rode with his children in a festively decorated horse-drawn carriage during the Labor Day parade. McCarthy served one term before being defeated for reelection.

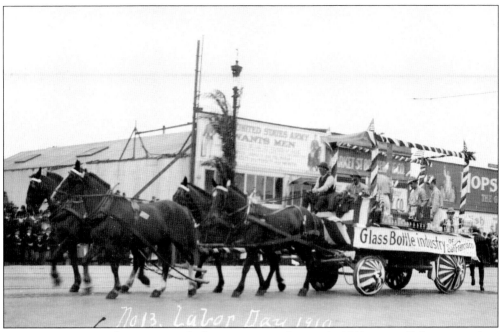

The San Francisco Labor Day parade down Van Ness Avenue in 1910 was well documented on photographic picture postcards. A team of four horses pulls a wagon of union workers for the Glass Bottle Industry of San Francisco past a recruiting sign that reads, "United States Army wants Men," and an advertising sign for "Hopsburger, the Golden Beer," on the right.

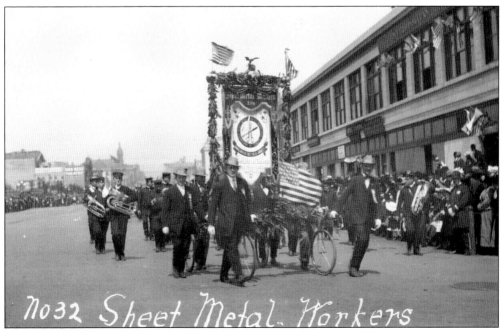

Members of the Sheet Metal workers Local 104 march past the Metropolitan Building on Van Ness Avenue in the September 1910 Labor Day parade. Men with bicycles lead the union in the parade, followed by a brass band.

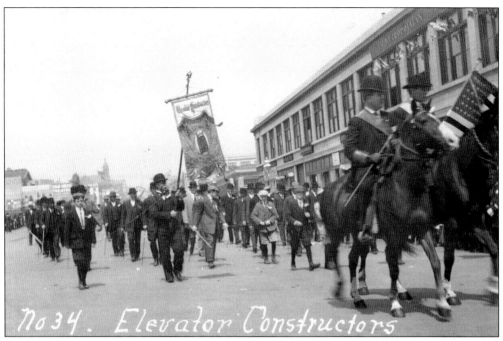

The Elevator Constructors IUSC Local 8 is marching past the Metropolitan Building on Van Ness Avenue in the 1910 Labor Day parade. Every member carries a walking stick as they follow behind their local's officers mounted on horseback.

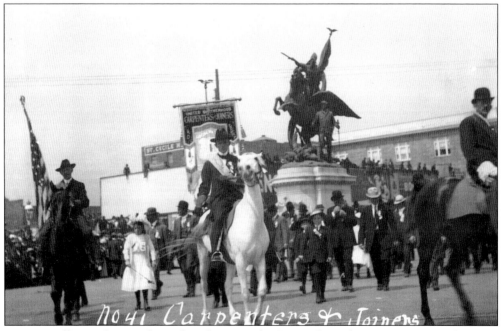

A union officer rides astride a white horse as the "United Brothers Carpenters and Joiners Union" marches past Douglas Tilden's "Soldiers Monument for the California Volunteers," then located on Van Ness Avenue near Market Street. In the informal 1910 Labor Day parade, the sons and daughters of union members marched alongside their fathers.

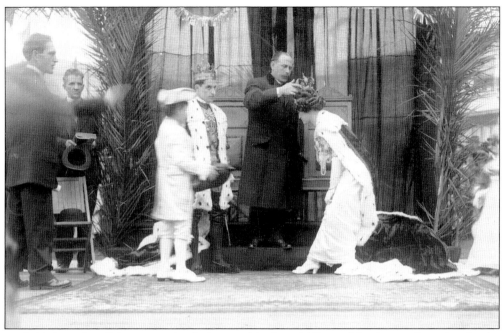

With his large handlebar mustache, hair parted in the middle, and frock coat, P. H. McCarthy looked every bit like a big-city mayor. He seemed to especially enjoy participating in special events such as the coronation of Queen California on Admission Day in 1910, as featured on this Charles Weidner photo postcard.

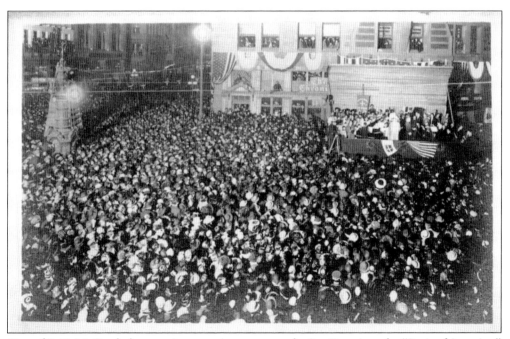

One of P. H. McCarthy's campaign promises was to make San Francisco the "Paris of America." On Christmas Eve 1910, opera diva Luisa Tetrazzini sang in the open air for a crowd estimated at 100,000, out of affection for the city that had shown her great public appreciation.

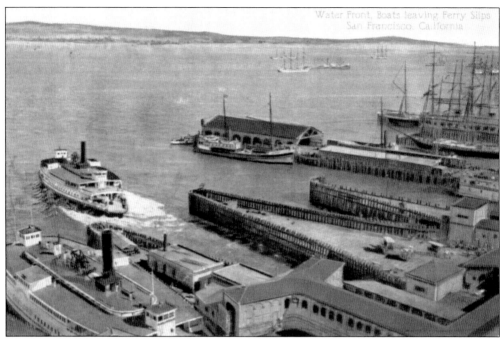

Ferryboats provided San Francisco's connection to towns and cities in the East Bay, the Delta, and Marin County. From the 1850s to the 1940s, the ferry vessels carried travelers. In 1898, the new San Francisco Ferry Building opened, providing a transit center for the entire Bay Area. This postcard shows the Bay City ferryboat departing from her slip behind the depot.

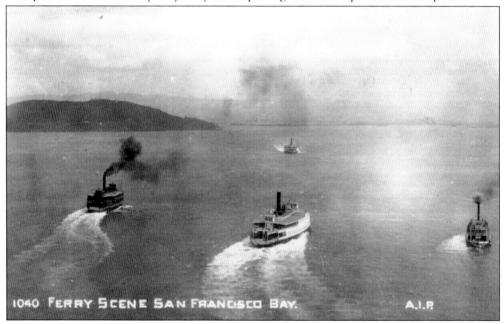

1040 FERRY SCENE SAN FRANCISCO BAY. A.I.P.

This "Ferry Scene San Francisco Bay" American Industrial Photo Company postcard from 1911 shows four single-stack ferryboats crossing San Francisco Bay. Ferryboat captains were forbidden to race on the bay. It was said that if Southern Pacific caught a captain racing, he would be fined $10. If he lost the race, he was fined $20.

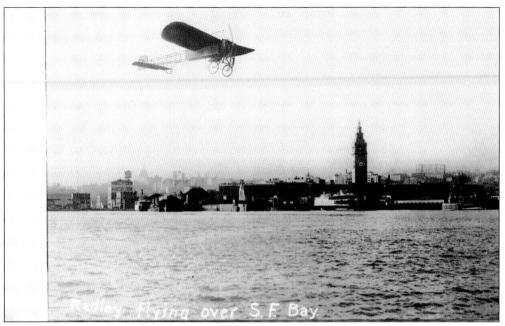

The 240-foot Ferry Building tower stands as a solitary sentinel as English aviator James Radley flies his monoplane over San Francisco Bay. Radley won a cross-country aviation race in October 1910, as part of a successful barnstorming tour across America. San Franciscans turned out in large numbers to see the aviation pioneer pictured in this 1911 Charles Weidner photo postcard.

French aviator Hubert Latham gets a bird's-eye view of San Francisco as he flies his monoplane "Antonette IV" over the city's business district. Latham and Radley gave spectators amazing aeronautical exhibitions. Latham, the first pilot to fly across the English Channel, would be killed in a crash less than a year after this Weidner photograph was taken.

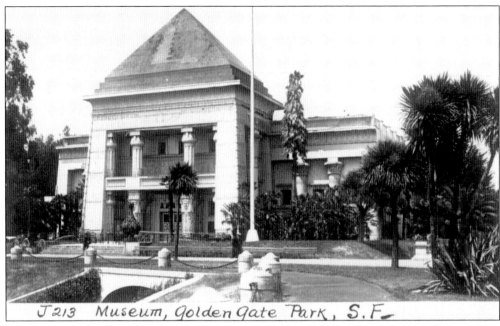

J 213 Museum, Golden Gate Park, S.F.

For recreation, San Franciscans took advantage of Golden Gate Park's 1,013 acres of long drives, lakes, baseball diamonds, tennis courts, bowling greens, children's playgrounds, and museums. The original fine arts museum was designed to look like an ancient Egyptian temple for the 1894 Midwinter Fair. Known as the Memorial Museum, it contained a mix of art, donated relics, and curiosities.

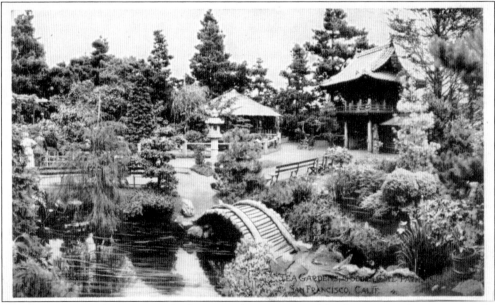

A bit of Japan in Golden Gate Park, the tea garden was created for the 1894 Midwinter Fair. The garden featured traditional architecture, artifacts, and plants. For the fair, Makoto Hagiwara was hired as curator. In 1900, a prejudicial city government took management of the tea garden away from Hagiwara. By 1907, the garden had fallen into disrepair and Hagiwara was asked to return as concessionaire.

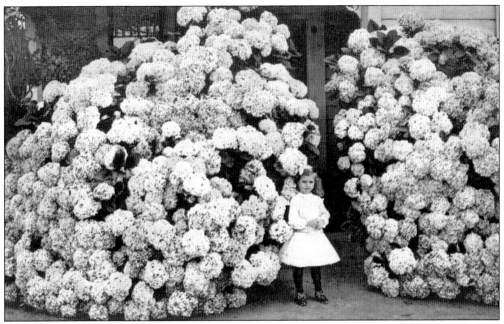

A young girl poses next to blossoming hydrangeas on this Edward Mitchell postcard. Park superintendent John McLaren provided innumerable flower beds and gardens, with more than 5,000 kinds of plants. McLaren was still superintendent of the park when he died at age 96 in 1943.

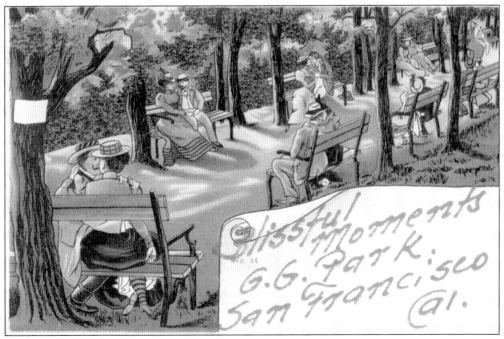

Some people came to enjoy more than just the park's plants, sports, and cultural facilities. From its earliest days, Golden Gate Park was a place for rendezvous and "blissful moments," as seen in this whimsical comic postcard mailed in 1909.

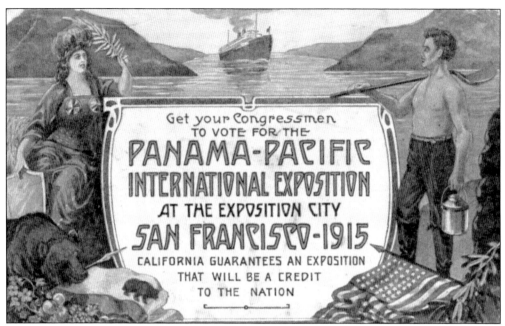

Get your Congressmen
TO VOTE FOR THE
PANAMA-PACIFIC
INTERNATIONAL EXPOSITION
AT THE EXPOSITION CITY
SAN FRANCISCO-1915
CALIFORNIA GUARANTEES AN EXPOSITION
THAT WILL BE A CREDIT
TO THE NATION

In 1910, the nation was getting ready to celebrate the completion of the Panama Canal with a world's fair. Several cities were in the running. San Francisco also wanted to celebrate its complete recovery from the 1906 disaster. Civic leaders started a massive writing campaign to get Congress to vote for San Francisco as the exposition city. This Sierra Art Company card is one of the postcards used to promote the city as the congressional choice.

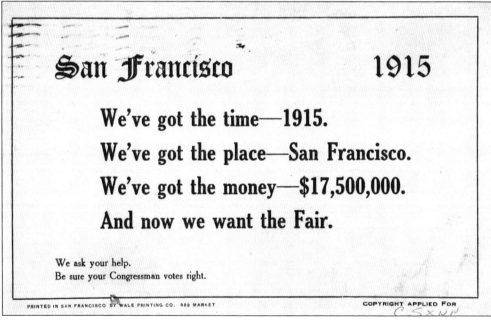

San Francisco 1915

We've got the time—1915.

We've got the place—San Francisco.

We've got the money—$17,500,000.

And now we want the Fair.

We ask your help.
Be sure your Congressman votes right.

PRINTED IN SAN FRANCISCO BY WALE PRINTING CO. 883 MARKET COPYRIGHT APPLIED FOR

By 1911, undaunted San Francisco, led by merchant Reuben Hale, got the word out that the city has raised $17,500,000 for the exposition. San Francisco won congressional approval by a vote of 188 to 159. On February 15, 1911, Pres. William Howard Taft signed a resolution designating San Francisco as the exposition city.

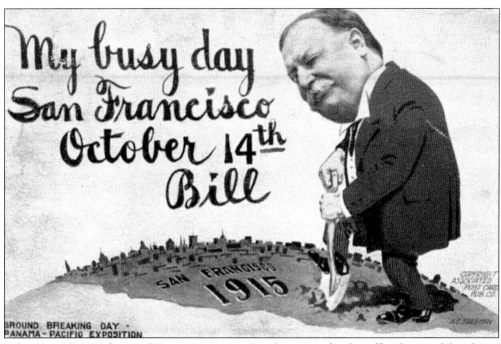

When President Taft visited San Francisco in October 1911, for the official ground-breaking, the actual location of the fair still had not been selected. The ceremony was held in the stadium in Golden Gate Park, where the president turned a symbolic clump of dirt with a silver shovel. The moment was preserved on this comic postcard.

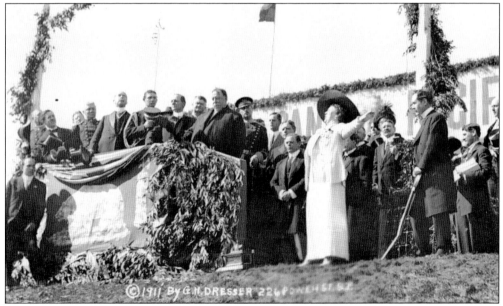

The ground-breaking ceremony in Golden Gate Park is pictured on a Dresser Studio photo postcard. President Taft is standing by as opera performer Lillian Nordica (Norton) provides a musical interlude. Madame Nordica, also known as "the Yankee Diva" and the "Lilly of the North," died of pneumonia before the fair opened. Exposition president Charles C. Moore stands to her right holding the silver shovel.

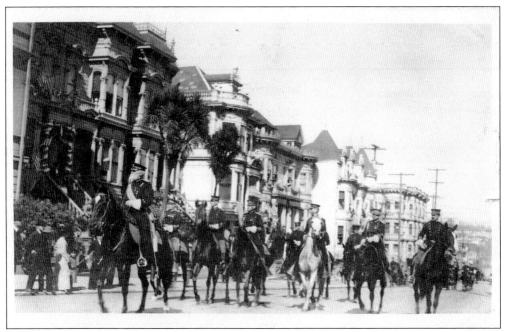

Participants in the president's visit, mounted army officers in full dress uniforms ride down the 900 block of Steiner Street in this photo postcard taken by amateur photographer F. C. O'Connor.

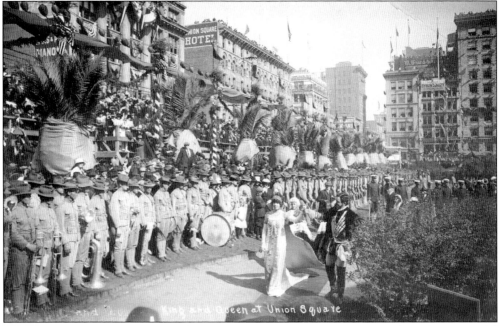

A second Portola Festival was held in October 1913. Attempting to relive the successful Portola Festival of 1909 and using the event as a practice for the Panama-Pacific International Exposition scheduled to open in less than 15 months, the city put on another good show, this time celebrating Vasco Nunez de Balboa's discovery of the Pacific. The ceremony shown on this photo postcard shows festival queen Conchita Sepulveda being escorted by "Balboa."

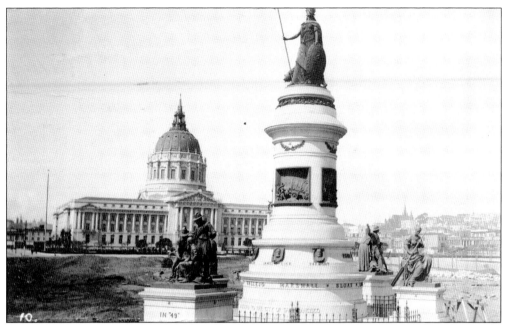

A bequest from James Lick provided the funds for the *Pioneer* monument constructed in 1894 by sculptor Frank Happersberger. Bronze figures symbolize California and the four major epochs of California history, including James Marshall's discovery of gold. Construction on the new city hall designed by architects John Bakewell Jr. and Arthur Brown Jr. was completed in 1915. The dome stood 308 feet above ground level, 16 feet and 2 5/8 inches higher than the Capitol in Washington, D.C.

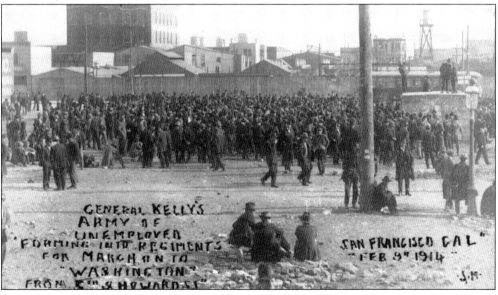

Pictured at Fifth and Howard Streets on February 9, 1914, is "General Kelly's army forming into regiments for the march on Washington." This is a photographic postcard showing the San Francisco contingent of Gen. Jacob Coxey's army of the unemployed. Twenty years earlier, Coxey led his first march. The San Franciscans would be addressed by Coxey, who advocated public works programs to provide jobs.

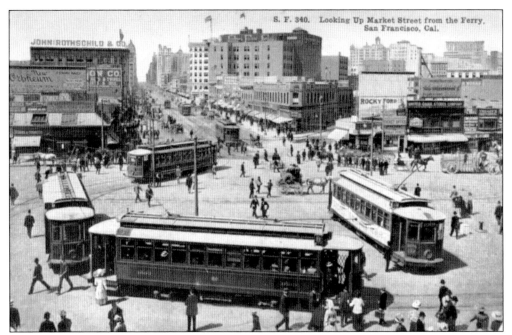

This is the streetcar loop, "looking up Market Street from the Ferry building." Four sets of electric streetcar tracks ran down Market Street. New routes were also established by 1914, and the new Stockton Street tunnel was completed to provide quick access to the fairgrounds. The car on the right sports a banner that it is a sightseeing car.

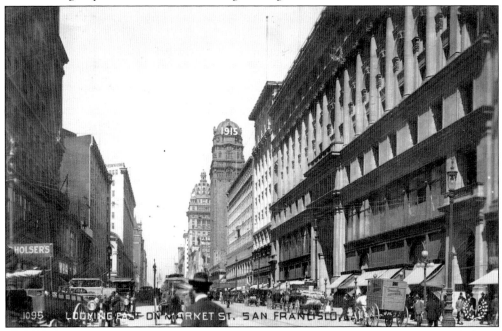

"Looking east on Market Street," the American Industrial Photo Company postcard shows horse-drawn wagons still on the thoroughfare in this view taken in front of the Emporium Department Store. The Humboldt Bank tower sports "1915" in large white numbers. Everyone knew that meant the world's fair was on its way.

Five

PANAMA–PACIFIC
INTERNATIONAL
EXPOSITION

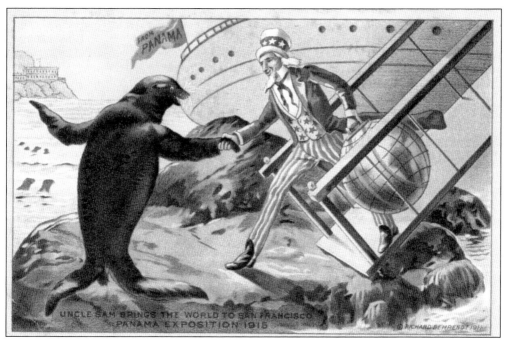

The Panama-Pacific International Exposition officially opened February 20, 1915. The city finally had its great celebration of recovery from the earthquake and fire. The world's fair was a symbol to the world of San Francisco's progress and prosperity. In the unforgettable exposition, San Francisco would welcome the world. Publisher Richard Behrendt issued a postcard showing a seal welcoming Uncle Sam bringing the "world" to San Francisco. When the fair closed on December 4, 1915, it was considered an unqualified success.

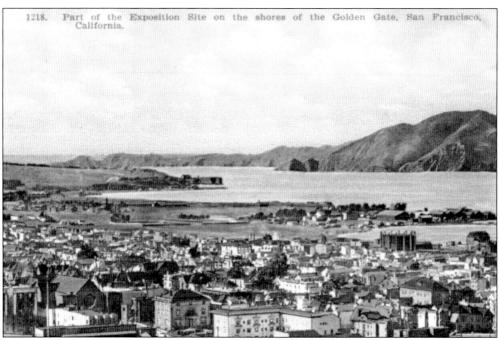

1218. Part of the Exposition Site on the shores of the Golden Gate, San Francisco, California.

This is a view of "part of the exposition site on the shores of the Golden Gate." Lake Merced, Golden Gate Park, Tanforan, Oakland Harbor, Alameda Flats, and Goat Island had all been suggested as possible sites before the Harbor View location was selected, along with portions of the Presidio and Fort Mason. The area was a mix of sloughs, wetlands, dairy farms, industry, and a resort. Several acres needed to be filled in before the fair opened.

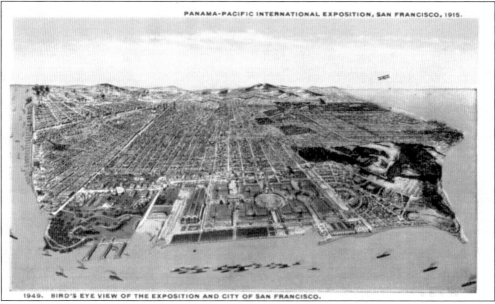

PANAMA-PACIFIC INTERNATIONAL EXPOSITION, SAN FRANCISCO, 1915.

1949. BIRD'S EYE VIEW OF THE EXPOSITION AND CITY OF SAN FRANCISCO.

"A bird's-eye view of the exposition and city of San Francisco." This Cardinell-Vincent postcard shows the width and breadth of the fair. The site covered a total of 625 acres. From the east, it extended from Van Ness Avenue, included a portion of Fort Mason, and extended through the present Marina District into the Presidio to the west end of the current Crissy Field.

The exposition directors established a committee of exploitation to publicize and promote the fair. Thousands of postcards were printed and mailed by the Exposition Publishing Company, such as this poster card, "California Welcomes the World," with a woman and bear covered with garlands of poppies symbolizing California.

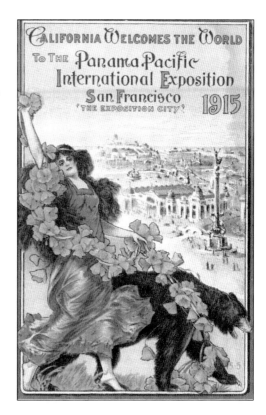

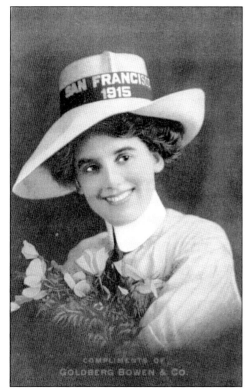

Private businesses were also involved with promoting the exposition. The Goldberg Bowen Company was a leading wholesale and retail grocer on the West Coast. They provided this complimentary "San Francisco 1915" postcard of a young woman wearing a Panama hat with a hatband. The message on the back read, "The wonders of the Globe will be exhibited in San Francisco. Come to unrivaled and beautiful California."

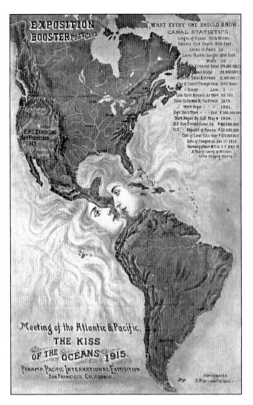

This Exposition Booster postcard did not forget that one purpose of the exposition was to celebrate the completion of the Panama Canal. A beautiful illustration credited to C. A. de Lisle Holland is titled, "Meeting of the Atlantic and the Pacific, the Kiss of the Oceans."

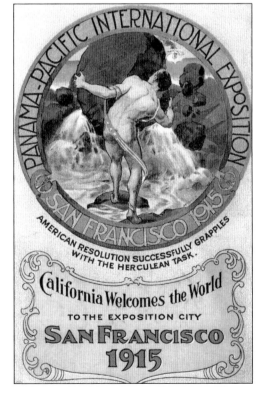

The official poster of the Panama-Pacific International Exposition featured a nude man strategically covered with a flag-like ribbon of cloth, opening up the Isthmus. The caption reads, "American Resolution successfully grapples with the Herculean task."

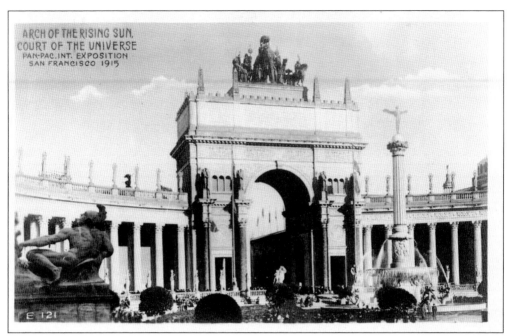

The central design of the exposition featured an array of grand boulevards, courtyards, artwork, and architectural monuments. This photo postcard shows the Arch of the Rising Sun, the eastern entry to the court of universe. The Nations of the East appear at the top of the arch. A figure representing the rising sun stands atop the column on the right. The statue on the left represents the element of fire.

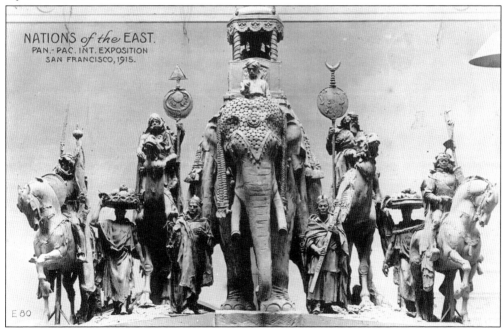

Even though it was located high above the crowds, on top of the Arch of the Rising Sun, sculptors A. Sterling Calder, Leo Lentelli, and Frederick Roth included amazing, realistic details. When the fair ended, the entire arch and sculpture were destroyed.

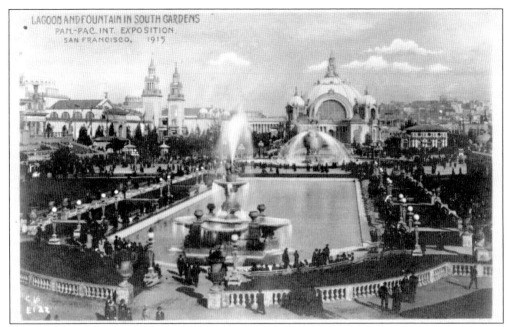

"The Lagoon and Fountain in South Gardens" were located near the main entrance. The domed building was the festival hall with a seating capacity for 4,000 people. On the rear left are the Italian towers. The gardens covered an area of about 1,200 feet by 700 feet. The plant beds featured a changing array of narcissus, pansies, daffodils, and tulips.

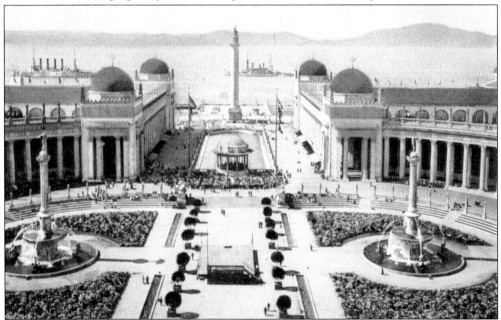

This is a Charles Weidner view from the Tower of Jewels of the Court of the Universe. This main central court led from the main entrance to the bay. The column on the right features the statue of the *Rising Sun*, and on the left column is the statue of the *Setting Sun*. In the center, an archer is at the top of the Column of Progress. Sousa's Band appeared at the bandstand in the middle of the card.

Sculptor Adolph Alexander Weinman created the statue, *Rising Sun*. The *Blue Book*, the official souvenir view book of the exposition, described the statue as "a joyous youth, a tiptoe, ready to commence his morning flight." The statue stood on the column on the eastern side of the Court of the Universe.

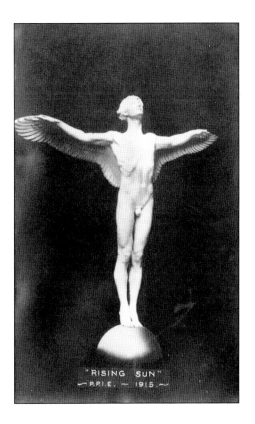

"RISING SUN"
~P.P.I.E. — 1915.~

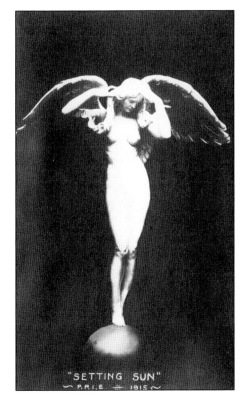

"SETTING SUN"
~P.P.I.E. — 1915~

The statue *Descending Night,* better known as the *Setting Sun,* was also the work of Weinman. The model was Audrey Munson. On the final night of the exposition, the lights were turned off one at a time. At midnight, the last light was a searchlight aimed at the *Setting Sun.* When it was turned off, there was not a dry eye on the grounds.

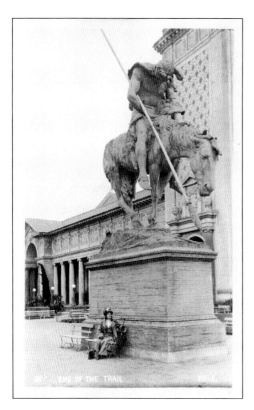

James Earl Fraser's classic masterwork *The End of the Trail* stood on its pedestal on the Avenue of the Palms near the Horticulture Palace. The worn-out warrior and spent horse symbolized the weariness of the native people in defeat. The poignant 25-foot-tall statue was one of the most popular works of art at the fair.

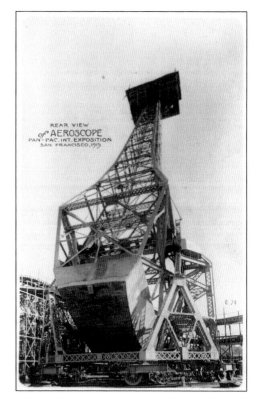

The Aeroscope, designed by Joseph Strauss, was the highest ride at the exposition, extended to a height of 285 feet. A passenger car had a capacity for 118 adult riders. Rides lasted 10 minutes, as the Aeroscope revolved in a circular manner.

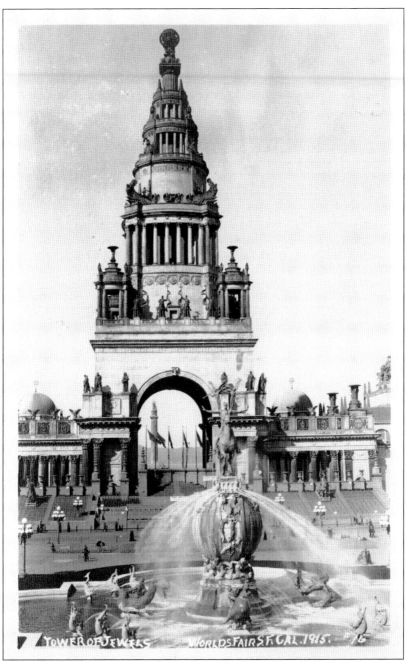

TOWER OF JEWELS WORLDS FAIR S.F. CAL. 1915.

The tallest and most imposing structure at the exposition was the Tower of Jewels. It was located midway between the main entrance at Scott Street and the Court of the Universe. The architect Thomas Hastings of New York designed a 435-foot-high tower that had no function but to be a beautiful landmark. The tower got its name from the over 125,000 Belgian cut-glass "Nova Gems" of eight different colors, which would gently swing when the wind blew. At night, spotlights illuminated the tower, producing an iridescent radiance. One guidebook described the tower as looking like it belonged in a fairy tale. The tower cost $413,000 to construct and $9,000 to demolish.

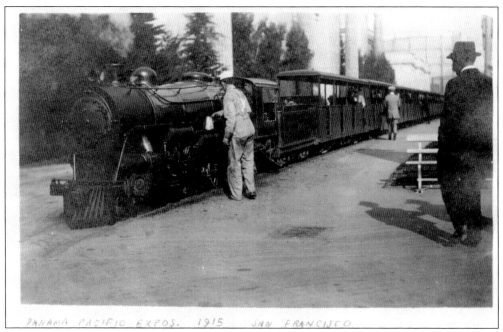

The Overfair Railway was a popular method of getting around the fairgrounds. The train ran from the Machinery Palace along the marina to the racetrack at the far west end of the grounds. The miniature steam locomotive and coaches were perfect models with air brakes, headlights, signals, and semaphores. The railway was 2.5 miles long and cost 10¢ to ride.

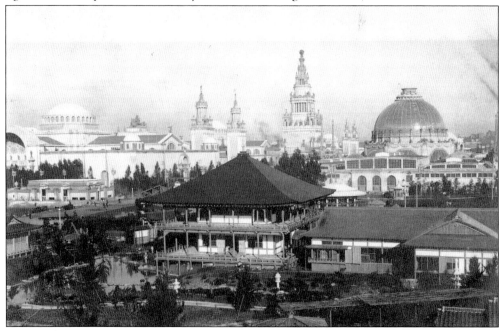

The 23 foreign pavilions were on 37 acres in the Presidio. For the Japan pavilion, using traditional tools, 50 Japanese workmen constructed an exact copy of a temple. There were 1,300 trees, 4,400 plants, plus turf, rocks, and stones brought from Japan for the garden. Bonsai trees would become popular in California after being shown at the exposition.

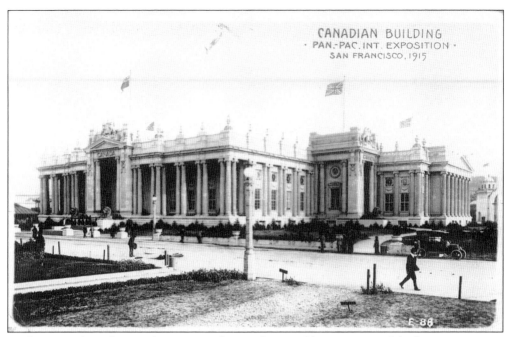

With 75,000 feet of space, the neo-Greek Canadian Building was one of the largest structures on the exposition grounds. The pavilion provided a remarkable display of Canadian life and history, with an indoor village, trading post, forest, streams, and a beaver pond.

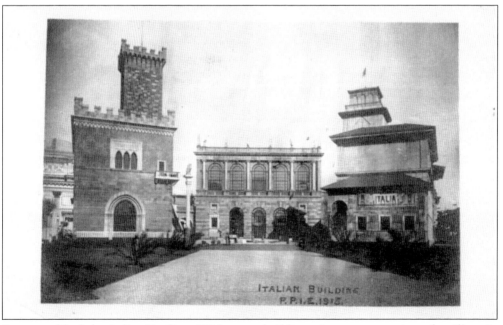

Everyone liked the Italian Pavilion. With seven buildings, it was a recreation of a village in Italy. The exhibits included art treasures and decorative displays of marble and bronze. The local Italian community celebrated Italian Day at the exposition with a huge turnout.

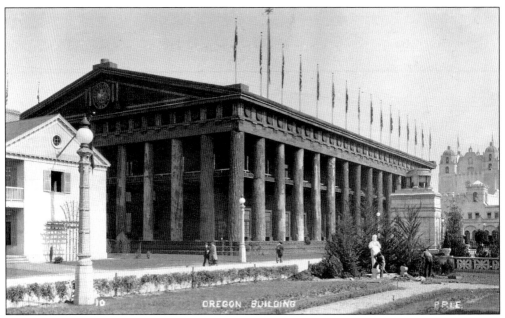

The state buildings were located on 40 acres in the Presidio. Twenty-four states and territories, plus New York City, were represented. Among the state buildings, the Oregon Pavilion was a standout, built entirely of Douglas fir and modeled after the Parthenon in Athens. It covered an area of 150 feet by 250 feet. The 251-foot flagpole was cut from a single stick of timber.

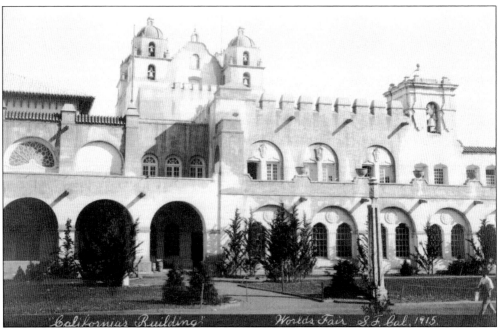

As the host state, the mission-style California building was the largest building with the exception of the exhibit palaces. It covered 5 acres, included seven bell towers, a spacious reception hall, and ballroom. The grounds included patios, fountains, and gardens. The exhibition area featured products and exhibits from each of the state's 58 counties.

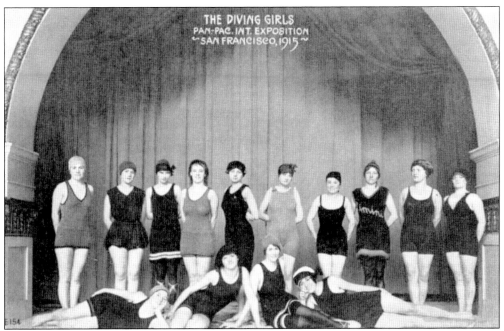

The "Zone" provided the amusement attractions at the fair. This Cardinell-Vincent postcard shows a little bit of cheesecake with the "Diving Girls" each wearing the latest in swimming attire. A guidebook described the "Diving Girls, each one of the eight a model figure, hold high carnival here in a performance of grace, beauty, and perfection in skill."

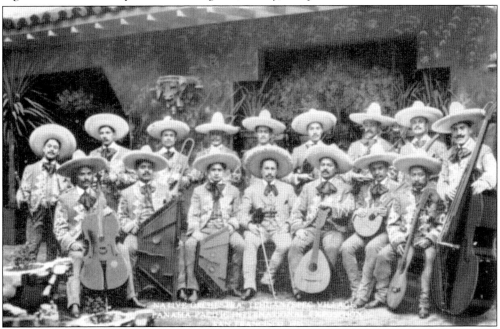

While the U.S. Army was on the Texas–Mexico border readying to chase Pancho Villa, the Mexican orchestra of the Tehuantepec Village provided lively performances of song and music. The musicians accompanied elaborate and lively dance performances. Visitors to the village could also purchase traditional crafts made on the premises.

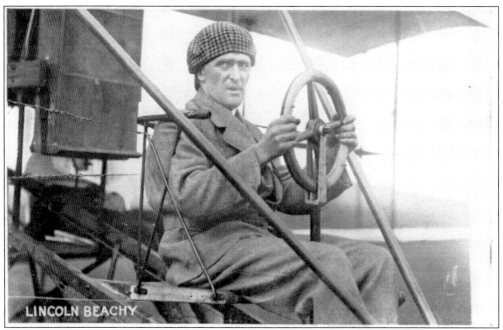

"The man who owns the sky;" Lincoln Beachey made flight history when he flew his aircraft indoors through the Palace of Machinery. On opening day, the San Francisco native flew over the crowd releasing two white doves. On March 12, 1915, Lincoln Beachey gave his last performance when his plane malfunctioned and crashed into the bay. Beachey survived the crash but drowned tangled in his harness. His name was misspelled on the postcard.

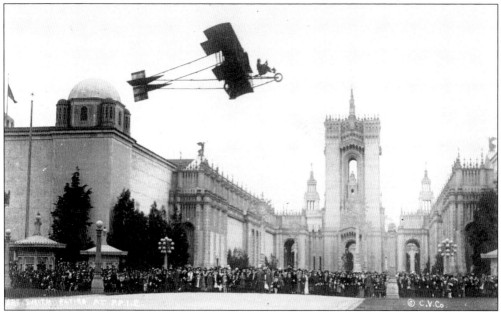

Despite Beachey's death, aviation remained a popular feature at the exposition. Aviators Silvio Pattirossi and Charles Niles made appearances. One of the most popular daredevil pilots was the "Bird Boy" Art Smith, seen in this photo postcard flying past the Mulgardt Tower as the crowd looks up in awe.

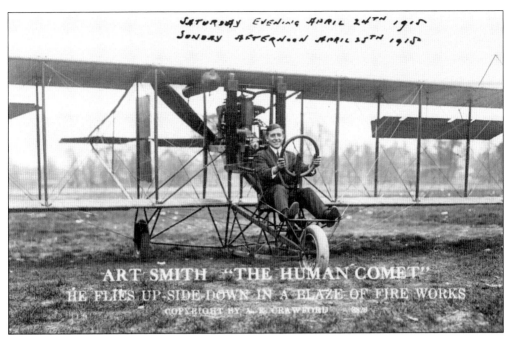

Art Smith was a talented and fearless pilot. He was also an unabashed self-promoter, as seen on this postcard advertising "The Human Comet." "He flies up-side down in a blaze of fireworks." Smith sold postcards of himself with former President Roosevelt, driving a miniature racecar, and posing inside the barrel of cannon at the Presidio. At night, he would fly his aircraft with flares attached to the wings for a dazzling effect.

The popularity of flight in 1915 can be seen in this arcade photo postcard of a father and son posing on a mock aircraft flying over an illustration of San Francisco and the bay. Perhaps the lad is imagining himself as the next "Bird Boy" or the next "man who owns the sky."

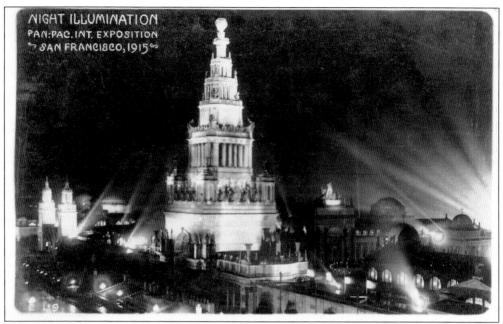

NIGHT ILLUMINATION
PAN-PAC.INT. EXPOSITION
SAN FRANCISCO, 1915

In this photographic postcard view, "Night Illumination," the Tower of Jewels is spectacularly illuminated from a variety of light sources. To the right, flashes of scintillator lights appear. The scintillator was a battery of searchlights on a breakwater in the marina. Colored screens were used to create a dazzling light show.

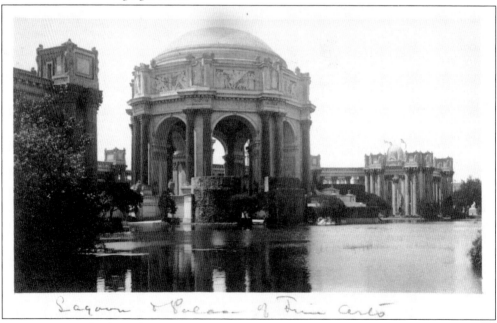

"The Lagoon and Palace of Fine Arts," designed by Bernard Maybeck, was considered to be the most beautiful individual building at the exposition. The palace consisted of a domed rotunda, dramatic colonnade, and in the rear, a steel frame building for art galleries. The exposition closed after 288 days with a paid attendance of 18,876,438. Meant to be a temporary construction, a rebuilt palace remains today as a relic of the Panama-Pacific International Exposition.

Six

Twentieth-Century San Francisco

With the Panama-Pacific International Exposition, San Franciscans proved that they could overcome adversity and still put on a good show. No one epitomized the city's success more than Mayor "Sunny Jim" Rolph, seen here astride a white horse at the May 1917 Rose Carnival. Rolph was not only colorful, but he was also competent. "Sunny Jim" would hold the office of mayor for 19 years until his election as governor. "Keep building with Rolph" was his favorite campaign slogan, and in the next few decades, Rolph would lead San Francisco into an era of further progress and growth.

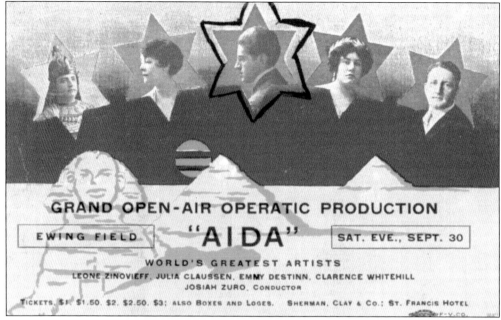

GRAND OPEN-AIR OPERATIC PRODUCTION

| EWING FIELD | "AIDA" | SAT. EVE., SEPT. 30 |

WORLD'S GREATEST ARTISTS
LEONE ZINOVIEFF, JULIA CLAUSSEN, EMMY DESTINN, CLARENCE WHITEHILL
JOSIAH ZURO, CONDUCTOR

TICKETS, $1, $1.50, $2, $2.50, $3; ALSO BOXES AND LOGES. SHERMAN, CLAY & CO.; ST. FRANCIS HOTEL

San Franciscans have always loved their opera. A special outdoor performance of "Aida" was scheduled for September 30, 1916, at Ewing Baseball Field near Masonic Avenue and Anza Street. Performers included young maestro Josiah Zuro, tenor Leone Zinovieff, bass-baritone Clarence Whitehill, renowned Czech soprano Emmy Destinn, and mezzo-soprano Julia Claussen. Twenty thousand tickets were sold, but a rainstorm forced the production to be moved inside to Civic Auditorium.

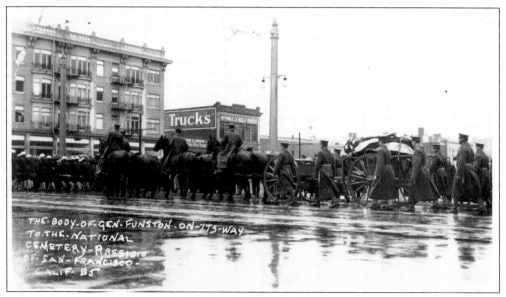

Maj. Gen. Frederick Funston, a hero of the 1906 earthquake and fire, died of a heart attack in 1917. San Franciscans remembered their hero, and Funston became the first person to lie in state in the new city hall from February 23 to 24, 1917. This photographic postcard shows the body of the general being escorted through the city for burial at the National Cemetery in the Presidio.

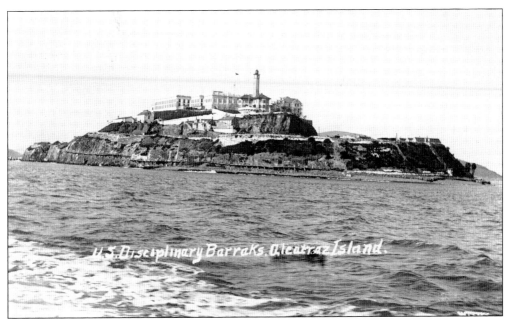

U.S. Disciplinary Barracks, Alcatraz Island.

"U.S. Disciplinary Barracks, Alcatraz Island," is a photo postcard showing the noted prison when the U.S. Army used the facility. A disciplinary barracks was not actually a prison but a place of discipline and education rather than confinement. The men were considered soldiers assigned to punishment companies. In 1934, the army relinquished control of the island, and it became a federal prison.

The U.S. Disciplinary Barracks mess hall does not look different from any other mess hall. The tables are set in a precise manner awaiting the arrival of the inmates. A dining room orderly stands behind a pillar. Inmates worked regular jobs and received instruction in vocational skills. Academic night classes were also offered. The emphasis of the disciplinary barracks was rehabilitation.

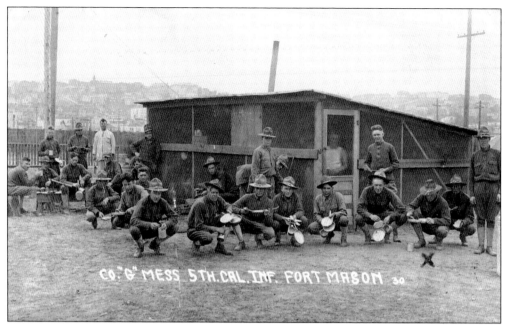

Troops from Company "G," 5th Infantry, California National Guard finish their supper while billeted at Fort Mason. The message on this photo postcard notes the fellow standing in the shack in his undershirt is the company cook. The man on his left in his pajamas has just returned from the hospital. The man squatting above the "X" wrote the message.

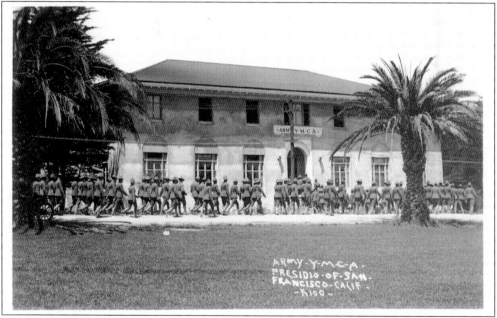

The United States declared war on Germany on April 6, 1917. The first officer training school for army enlisted men and civilian recruits opened at the Presidio five weeks later. After three months of training, they would be commissioned reserve officers. This postcard shows the officer candidates as they march past the YMCA in the Presidio.

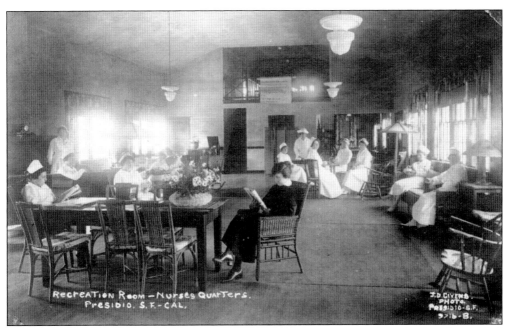

The United States entry into the war resulted in an increase in the number of sick and wounded admitted to Letterman Hospital and an increase in the hospital staff. In April 1917, there were 24 doctors and 48 nurses caring for 732 patients. In December 1918, there were 61 doctors and 182 nurses caring for 1,943 patients. This J. D. Givens photographic postcard shows the "recreation room in the nurse's quarters."

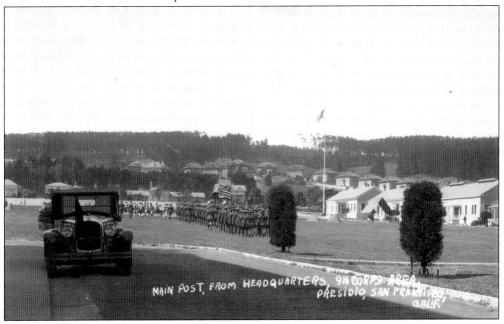

Soldiers march in formation in this view of the main post parade ground. Six thousand troops were billeted in temporary quarters in the North Cantonment next to the bay. At the Presidio, soldiers were permitted to go off post after duty hours. No passes were required. For most of its history, the Presidio was an open post, allowing civilians access to the post at any time.

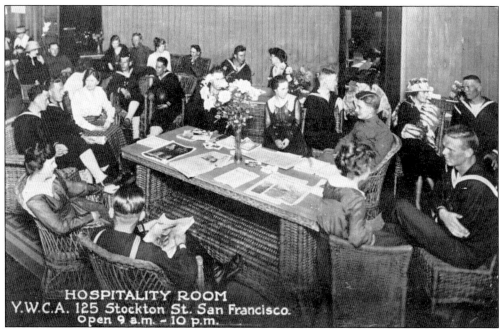

Sailors gather at the "Hospitality Room of the Y.W.C.A. 125 Stockton Street. Open 9 a.m. – 10 p.m." The YWCA provided an opportunity for the servicemen to meet with young women who served as hostesses in a wholesome environment.

Dignitaries, including Mayor James Rolph (standing) and U.S. senator James D. Phelan (top hat), wait on a flag draped reviewing stand for returning troops to march past city hall. The 363rd Infantry Regiment was known as "San Francisco's Own." The majority of the men in the regiment were from the city. One sergeant, Philip C. Katz, was awarded the Medal of Honor, and in a few years he would be elected to the board of supervisors.

The Democrats came to San Francisco in June 1920 for their national convention. This postcard shows 10 of the party's candidates for president, the St. Francis Hotel, and the Exposition Auditorium. After 44 ballots, Gov. James Cox of Ohio received the nomination. Assistant Secretary of the Navy Franklin Roosevelt was selected as Cox's running mate.

"Welcome President Harding, San Francisco, July 31, 1923." Warren Harding won a landslide victory over the Cox-Roosevelt ticket. In ill health, the 57-year-old Harding died at the Palace Hotel on August 3, 1923. A memorial funeral service for the popular president was held at city hall.

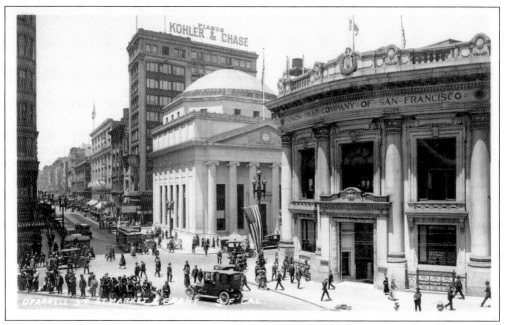

A busy intersection at O'Farrell, Market, and Grant Streets is shown in this 1923 postcard view. A cable car still runs on O'Farrell Street. Automobiles were now affordable and competed for parking space, as pedestrians appear to walk in every direction.

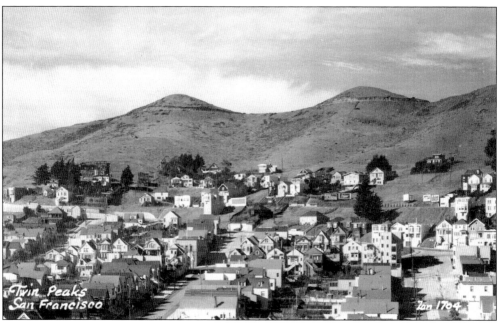

Twin Peaks, the hills that stand almost in the exact center of the city, provide exciting views for the homes midway up their slopes on this Zan Stark postcard. The Spanish romantically named the peaks Los Pechos de la Chola ("the Breast of the Indian Girl"). A curving road took sightseeing visitors to the windy 900-foot summit to enjoy the Bay Area wide views.

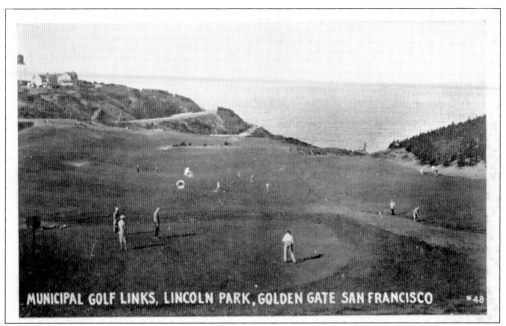

The postcard is of "the Municipal Golf Links, Lincoln Park." It was once said that, "From here, the noted golfer Bobby Jones could drive a ball right through the Golden Gate." The 18-hole course was once the site of cemeteries and potter's fields. Near the 15th green is a 24-foot bronze obelisk dedicated to the Ladies Seamen's Friends Society, honoring the master mariners once buried here.

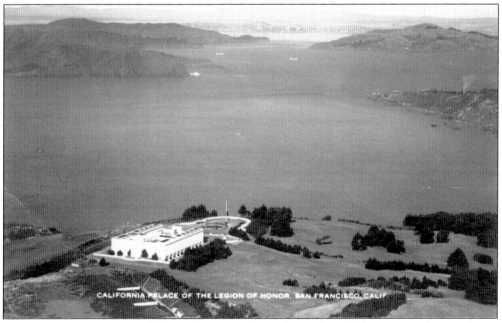

A dramatic postcard view of the Golden Gate shows the "Palace of the Legion of Honor" near Lincoln Park. The Legion of Honor was a gift to the city from Alma deBretteville Spreckels for use as a fine arts museum. The building, designed by George Applegarth and Henri Guillaume, is a three-fourth's scale imitation of the Palais de la Legion d'Honneur in Paris.

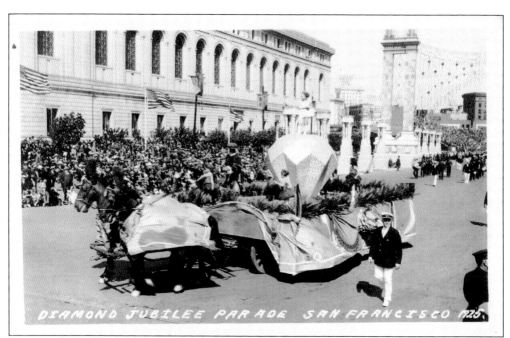

San Francisco celebrated California's Diamond Jubilee as a state from September 5 to September 12, 1925, with parades, athletic events, simulated air battles, banquets, and balls. In this photo postcard, a mule-team pulls a cart with a large diamond through the Arch of Progress on Fulton Street near the main public library.

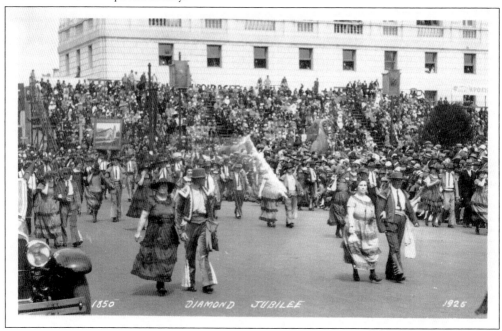

The Diamond Jubilee parade continues with marchers dressed in 19th century Spanish style outfits. Many participants were the descendants of the early Californios. Honored guests at the event included vice president Charles Dawes and a Covered Wagon Baby Revue of 45 mature adults born in covered wagons while their parents were en route to California.

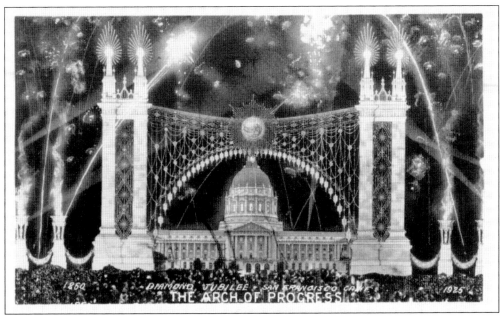

The Arch of Progress, also known as the jeweled arch, spanned Fulton Street. A brilliantly lit city hall appears in the background of this postcard night view. The arch was decorated with glass baubles left over from the 1915 Tower of Jewels. On either side of the arch were cauldrons issuing jets of colored steam. Illumination throughout the city was under the direction of General Electric's W. D'Arcy Ryan.

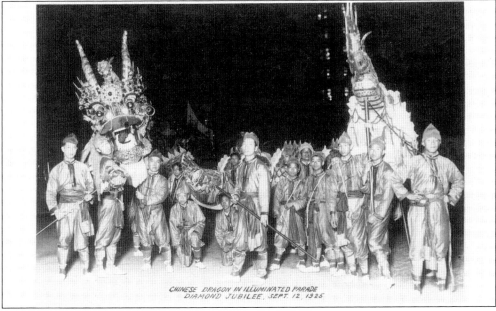

According to the postcard, there was a "Chinese Dragon in Illuminated Parade, Diamond Jubilee, September 12, 1925." San Francisco's Market Street "Path of Gold" was the route of the night parade. Over 300,000 spectators viewed the parade. Gum Lung, the golden dragon, brought the parade to a climax. This photo postcard shows the team of marchers who carried the dragon in the parade.

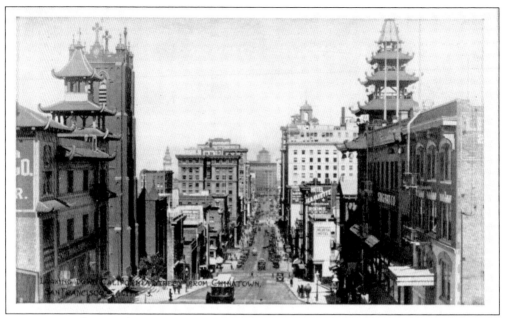

A 1920s view down California Street features Chinatown's two landmark bazaars, Sing Chong on the left and Sing Fat on the right. The architect for both buildings, T. Patterson Ross, designed pagoda-like towers to represent Chinese culture and art. The idea was to create the decorative look of an Oriental city that would attract tourists and non-Chinese visitors to the neighborhood.

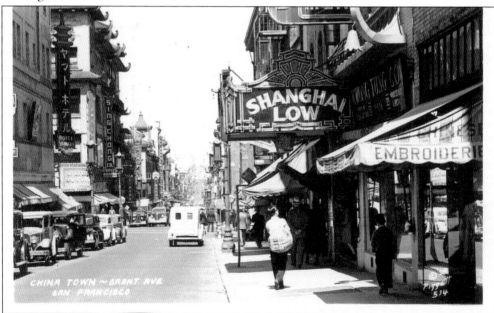

This J. K. Piggott photograph, labeled "China Town," shows Grant Avenue with a mix of restaurants and retail establishments. San Francisco's Chinatown was the largest community of Chinese in the United States, with an official census count of 16,303. While most businesses on Grant Avenue catered to the tourist trade, many businesses provided for the needs of the local community.

The "Pacific Telephone and Telegraph Company Building" was the first of San Francisco's great modern office buildings. Local architect Timothy Pflueger designed the corporate headquarters at 140 New Montgomery Street with gray granite-like terra-cotta. At 435 feet, the building stood out as the only high-rise building south of Market Street and appeared on numerous postcard views of the city.

The distinctive Hunter-Dulin Building at 111 Sutter Street was designed by the New York architectural firm Schultze and Weaver in 1926 for a Los Angeles investment firm. The Romanesque building with a copper-plated mansard roof has decorative terra-cotta falcons. Author Dashiell Hammett placed his fictional private detective Sam Spade's office in the Hunter-Dulin.

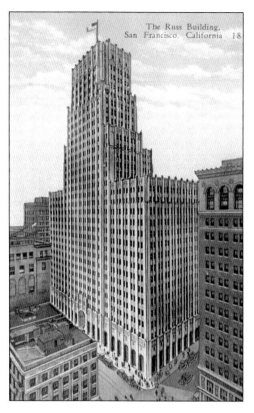

Prolific San Francisco architect George Kelham designed the Russ Building in 1927. This postcard shows the massive high-rise at 235 Montgomery Street when it was the city's tallest building. It was also the first city office building to have it's own parking garage located in the building itself as well as a service floor to provide for the personal needs of the building's businessmen with a variety of shops including a barbershop, stenographer service, and telephone directory service.

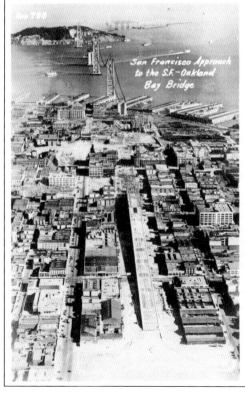

Despite the Depression, the San Francisco landscape and transportation system were about to experience major changes with the building of the Oakland-Bay Bridge and Golden Gate Bridge. This aerial postcard view shows the Bay Bridge under construction and a new approach to the bridge cutting through the South of Market district.

114

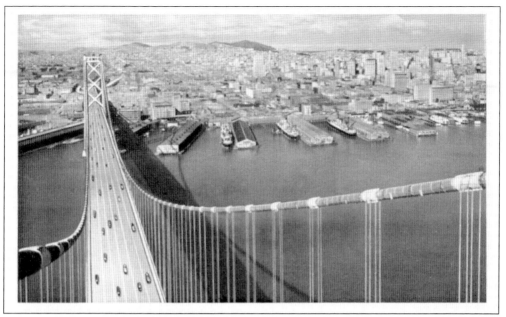

A view of the upper deck of the Bay Bridge taken from the bridge tower provides a unique view of the city from the waterfront to Twin Peaks. Originally, the upper level allowed for automobile traffic going both westbound and eastbound. The lower level was restricted for use by the Key System train service and for large trucks. The towers stood 526 feet above the water. The total length of the entire bridge structure was 8.25 miles.

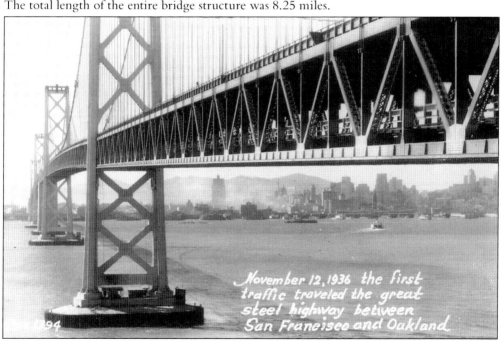

An unusual postcard view of the bridge and San Francisco skyline on "November 12, 1936 the first traffic traveled the great steel highway between San Francisco and Oakland." The official name of the bridge was the James Rolph Jr. Memorial Bridge, but it has always been better known as the San Francisco–Oakland Bay Bridge, or just the Bay Bridge.

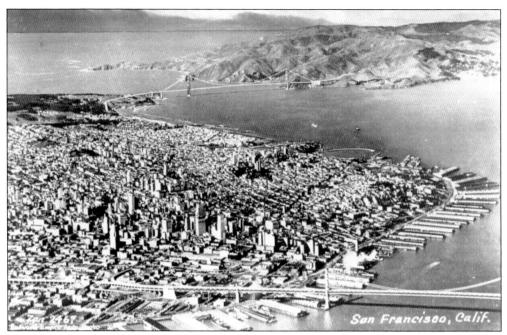

Zan Stark photographed this dramatic aerial view of San Francisco after the completion of the city's two bridges. Joseph B. Strauss designed San Francisco's second great engineering marvel, the Golden Gate Bridge, a 6,450-foot, single-span suspension bridge with towers reaching a height of 746 feet above the water.

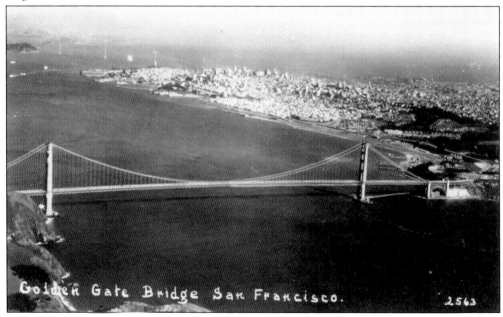

This is the Golden Gate Bridge and the city viewed from the Marin Headlands. The Golden Gate Bridge immediately became San Francisco's most iconic landmark. The completion of the bridge and official opening was celebrated with a weeklong Golden Gate Bridge Fiesta from May 27 to June 2, 1937. On May 28, 1937, Pres. Franklin Roosevelt pressed down a telegraph key to officially open the bridge to automobiles.

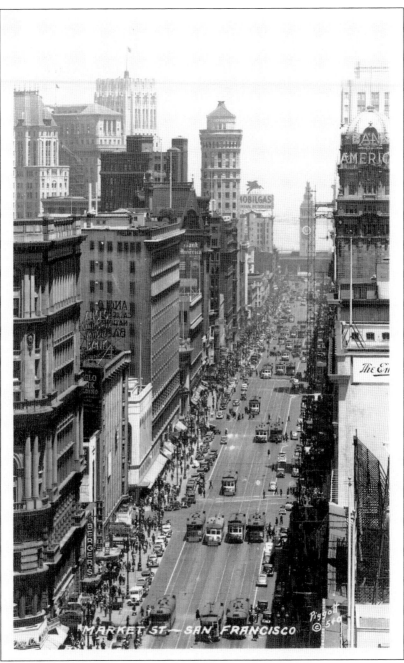

Dozens of streetcars travel down four separate lines of track in this dramatic 1930s Market Street photo postcard by J. K. Piggott. All downtown streets converge into Market Street from every direction. The street is 120 feet wide and runs from the Ferry Building at its east end to the lower slopes of Twin Peaks at its west end. When this photograph was taken, Market Street was a popular and busy destination with a mix of commercial and social activities. Grand theaters, luxury hotels, department stores, and office buildings were all part of the mix on this dynamic boulevard, and no proper San Franciscan would visit Market Street without being properly attired in their best clothes and hats.

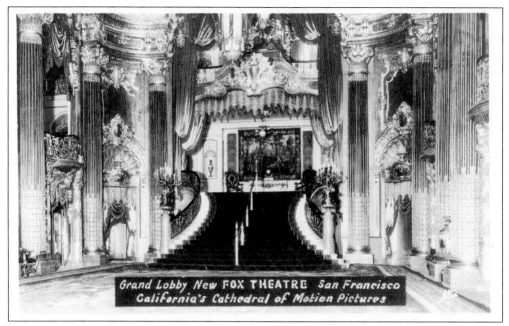

This is the "Grand Lobby New Fox Theatre, California's Cathedral of Motion Pictures." The caption on the postcard says it all. Once the largest movie theater in the world, with 5,000 seats, it was elaborately decorated with gilded baroque carvings and velvet drapes. Theater magnate William Fox claimed the theater cost $5,000,000 to build and decorate. Actors Gary Cooper and Will Rogers were among the celebrities who attended the June 28, 1929, opening.

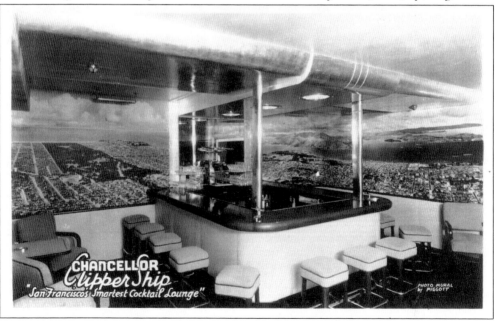

A more sublimely decorated facility was the Powell Street Chancellor Hotel's Clipper Ship Lounge, "San Francisco's Smartest Cocktail Lounge." The room celebrated the China Clipper Trans-Pacific Airline with art deco aeronautical inspired decor and a large mural of the San Francisco Bay Area by noted postcard photographer J. K. Piggott.

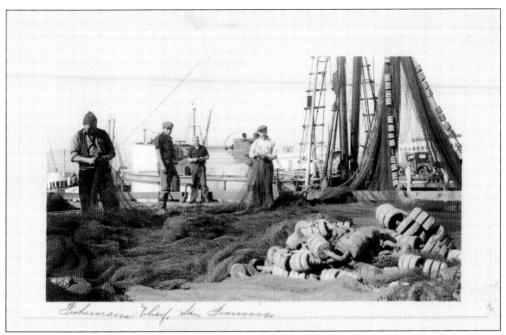

The first Italian fisherman arrived in the city in the early 1880s and settled on the northern tip of San Francisco. By 1900, harbor authorities set aside Jefferson Street from Taylor to Leavenworth Streets for commercial fishermen. The area soon became a popular destination when the fishermen began selling their catch from their boats and eventually establishing restaurants.

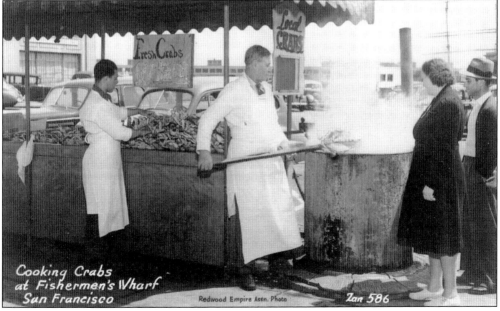

This photo postcard by Zan Stark features "Cooking Crabs at Fisherman's Wharf." In the 1930s, the most popular seafood was inexpensive crab purchased at walk-away stands, and a favorite dish was a salad of crabmeat doused with Thousand Island dressing called Crab Louis. In the 1930s, Fisherman's Wharf was no longer just a workplace but also a favorite tourist destination.

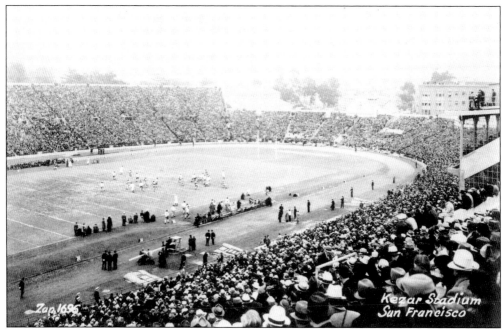

Kezar Stadium on the edge of Golden Gate Park, as seen in this Zan Stark photograph, was used as a football field for the city's high schools and the Catholic universities, St. Mary's, Santa Clara, and San Francisco. During the 1940s and 1950s, Kezar was the home of the San Francisco 49ers. From its opening in 1925, spectators sat on backless, wooden benches, providing a seating capacity for 60,000 fans.

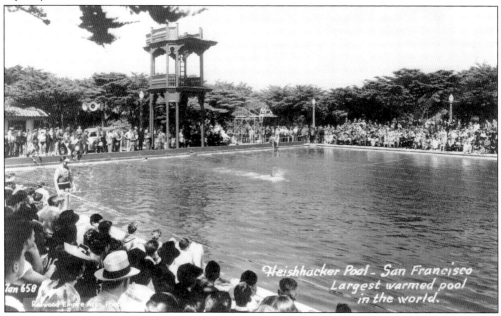

Zan Stark produced this view of "Fleishhacker Pool, the largest warmed pool in the world." The pool was 1,000 feet long and 150 feet wide. With depths varying from 3 to 14 feet, the pool contained 6 million gallons of heated seawater. Due to the large size of the pool, lifeguards tended to their duties using rowboats.

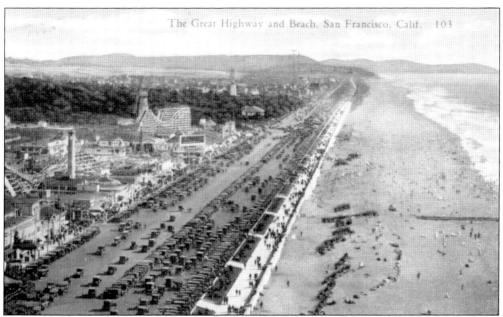

"The Great Highway and Beach" postcard shows a view of Playland. The amusement park featured merry-go-rounds, a roller coaster, diving bell, and various other rides, mixed with carnival skill games of chance and shooting galleries. A favorite destination was the fun house where visitors were greeted by "Laughing Sal" and could ride down a very long slide sitting on gunnysacks.

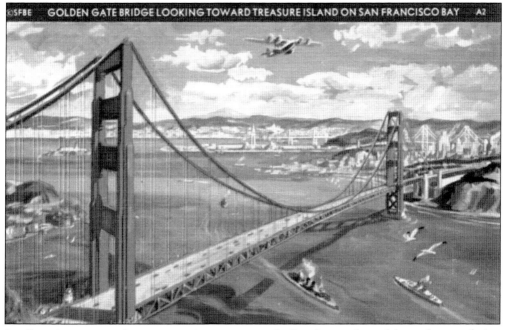

GOLDEN GATE BRIDGE LOOKING TOWARD TREASURE ISLAND ON SAN FRANCISCO BAY A2

San Franciscans wanted an opportunity to promote the Bay Area and to celebrate the completion of great bridges with a world's fair. The Golden Gate International Exposition opened on February 18, 1939. This promotional postcard features a painted view of the Golden Gate Bridge with the site of the fair, Treasure Island, in the background.

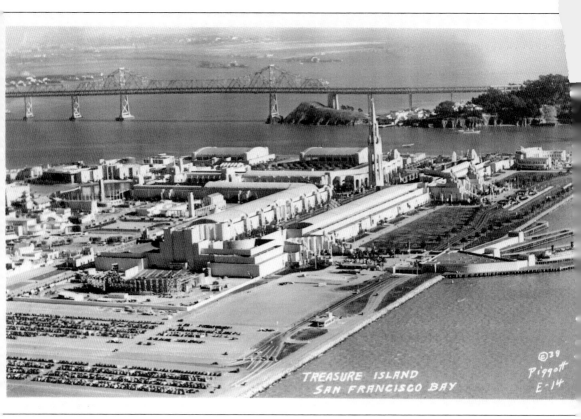

TREASURE ISLAND
SAN FRANCISCO BAY

©39
Piggott
E-14

There was no available land in San Francisco for a world's fair. It was decided that a man-made island would be created for the event. After completion of the exposition, the plan was to convert the island into an international airport. Named Treasure Island, the fair site was located in the center of San Francisco Bay near Yerba Buena Island and the Oakland-Bay Bridge. Treasure Island was constructed mostly from mud dredged from the bay on a shallow shoal. When completed, the small island was about 1 mile long and two-thirds of a mile wide, covering about 400 acres. The theme of the Golden Gate International Exposition was the Pacific and the future. The fair design would be a blend of modern art and architecture with the arts and cultures of the nations of the Pacific. This J. K. Piggott photo postcard provides a view of Treasure Island with the 400-foot-high Tower of the Sun in the center. Unlike the 1915 Panama-Pacific International Exposition, the 1939 fair lost money, and in an attempt to regain financial losses, it reopened again in May 1940.

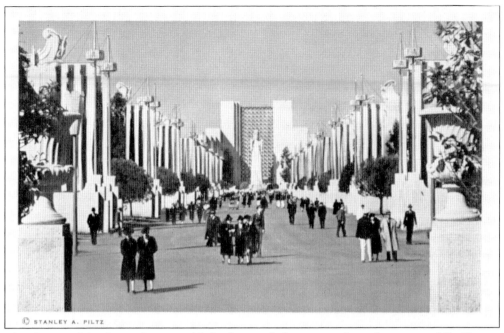

© STANLEY A. PILTZ

The Court of the Seven Seas provided a banner-laden approach to the statue of *Pacifica*, an 80-foot-high plaster statue of a female figure, created by sculptor Ralph Stackpole. The statue stood in front of a 100-foot-high prayer curtain of connected metal stars and tubes. At night, theatrical lighting created an ethereal background of changing colors for *Pacifica*.

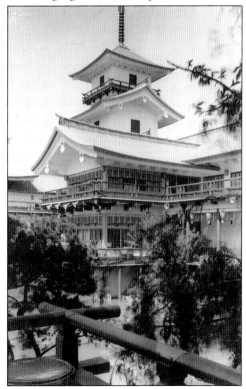

Despite continuing worsening relations between Japan and the United States, the Japanese Pavilion was one of the most popular and successful exhibits at the fair with its Samurai castle, pagoda, terraced gardens, and Koi fishpond. A year after the exposition closed, the United States and Japan would be at war, and Treasure Island would be converted to a major Pacific Coast naval base.

The New "ICE FOLLIES OF 1940", World's Greatest Musical Revue on Ice

This is a promotional postcard for "The New 'Ice Follies of 1940,' World's Greatest Musical Revue on Ice." Even without snow and ice, San Franciscans have always loved ice-skating performances. Appearing at the Winterland Auditorium, the Shipstad and Johnson Ice Follies was a touring ice show featuring elaborate musical production numbers.

On a sunny day in San Francisco, before World War II, this Zan Stark photographic postcard shows two young girls as they sit on the edge of a civic center fountain feeding the pigeons. Civic Auditorium (formerly Exposition Auditorium, now renamed Bill Graham Auditorium) is in the background.

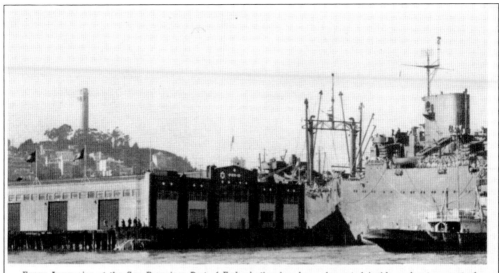

Every Army pier at the San Francisco Port of Embarkation has been decorated inside and out as part of Major General Homer M. Groninger's *Welcome Home* program for returning soldiers. Picture shows the exterior decoration of Pier 15, main debarkation center of San Francisco Port of Embarkation.

During World War II, San Francisco was a major port of embarkation for troops leaving for the Pacific Theater. Thousands of men and women passed through the city on their way to and from the war. This 1945 postcard shows a returning Liberty ship at Pier 15 with "welcome home" banners.

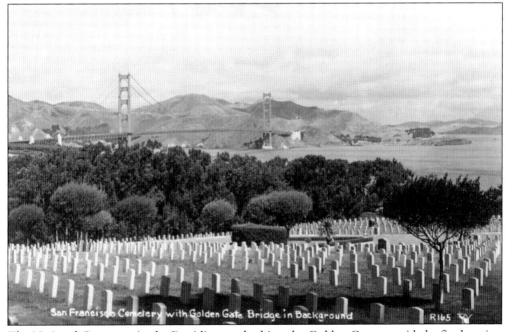

The National Cemetery in the Presidio, overlooking the Golden Gate, provided a final resting place for many veterans of the war. At nearby Letterman General Hospital, admissions reached an all-time high during World War II. From 1941 to 1946, the hospital admitted a total of 193,429 patients.

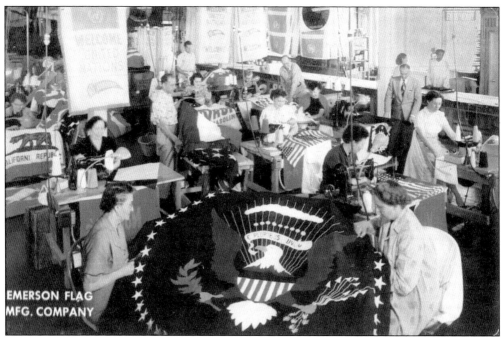

The Emerson Flag Manufacturing Company showed off their detailed handmade work in this advertising postcard promoting their new plant at 21 Hawthorne Street. In the foreground, the president's flag for the St. Francis Hotel is being sewed, while numerous "Welcome United Nations" banners hang awaiting delivery.

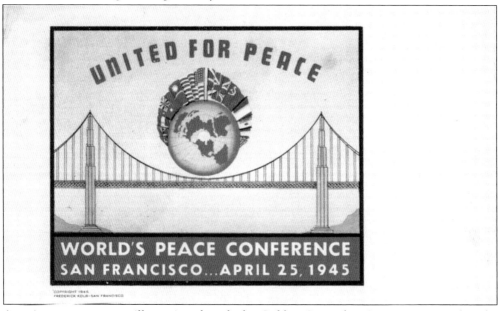

American troops were still pouring though the Golden Gate when it was announced at the Yalta Conference in the far off Crimea that San Francisco would be the host city for a world peace conference of the United Nations on April 25, 1945. San Franciscans watched for two months as diplomats at the War Memorial Opera House and Veterans Building framed the charter for the United Nations. This postcard commemorates that event.

BIBLIOGRAPHY

American Guide Series, Compiled by Workers of the Writers' Program of the Works Projects Administration in Northern California. *San Francisco, the Bay and Its Cities*. New York, NY: Hastings House, 1947.

Benet, James. *A Guide to San Francisco and the Bay Region*. New York: Random House, 1963.

Bowen, Robert W. *San Francisco's Presidio*. Charleston, SC: Arcadia Publishing, 2005.

Bowen, Robert W. and Brenda Young Bowen. *San Francisco's Chinatown*. Charleston, SC: Arcadia Publishing, 2008.

Corbett, Michael R., Prepared by Charles Hall Page and Associates Inc. for the Foundation for San Francisco San Francisco's Architectural Heritage. *Splendid Survivors, San Francisco's Downtown Architecture*. San Francisco, CA: California Living Book, 1979.

Crowe, Michael F. and Robert W. Bowen. *San Francisco Art Deco*. Charleston, SC: Arcadia Publishing, 2007.

Koch, Glenn D. *San Francisco: Golden Age of Post Cards*. Sausalito, CA: Windgate Press, 2001.

Lewis, Oscar. *San Francisco, Mission to Metropolis*. Berkeley, CA: Howell-North Books, 1966.

Lockwood, Charles. *Suddenly San Francisco, The Early Years of an Instant City*. San Francisco, CA: California Living Book, 1978.

Martini, John A. *Fortress Alcatraz, Guardian of the Golden Gate*. Kailua, HI: Pacific Monograph, 1990.

McGloin, John B., S.J. *San Francisco, The Story of a City*. San Rafael, CA: Presidio Press, 1978.

Milliken, Randall. *A Time of Little Choice, The Disintegration of Tribal Culture in the San Francisco Bay Area 1769–1810*. Menlo Park, CA: Ballena Press, 1995.

Panama-Pacific International Exposition Company. *The Blue Book, A Comprehensive Official Souvenir View Book of the Panama-Pacific International Exposition at San Francisco 1915*. San Francisco, CA: Robert A. Reid, Official Publisher of View Books, 1915.

Ryan, Dorothy B. *Picture Postcards in the United States 1893-1918*. New York, NY: Clarkson N. Potter, Inc. 1982.

San Francisco Bay Area Post Card Club. *Facing Disaster, A Centennial Postcard Album of the San Francisco Earthquake and Fire April 1906*. Penngrove, CA and Oakland, CA: San Francisco Bay Area Postcard Club and Quantity Post Cards, 2006.

San Francisco Board of Supervisors. *San Francisco Municipal Reports for the Fiscal Year 1908–9, Ended June 30, 1909*. San Francisco, CA: Neal Publishing Company, 1910.

www.arcadiapublishing.com

Discover books about the town where you grew up, the cities where your friends and families live, the town where your parents met, or even that retirement spot you've been dreaming about. Our Web site provides history lovers with exclusive deals, advanced notification about new titles, e-mail alerts of author events, and much more.

MADE IN THE USA

Arcadia Publishing, the leading local history publisher in the United States, is committed to making history accessible and meaningful through publishing books that celebrate and preserve the heritage of America's people and places. Consistent with our mission to preserve history on a local level, this book was printed in South Carolina on American-made paper and manufactured entirely in the United States.

This book carries the accredited Forest Stewardship Council (FSC) label and is printed on 100 percent FSC-certified paper. Products carrying the FSC label are independently certified to assure consumers that they come from forests that are managed to meet the social, economic, and ecological needs of present and future generations.

FSC
Mixed Sources
Product group from well-managed forests and other controlled sources

Cert no. SW-COC-001530
www.fsc.org
© 1996 Forest Stewardship Council

Find Your Place in History.